GWEN JOHN

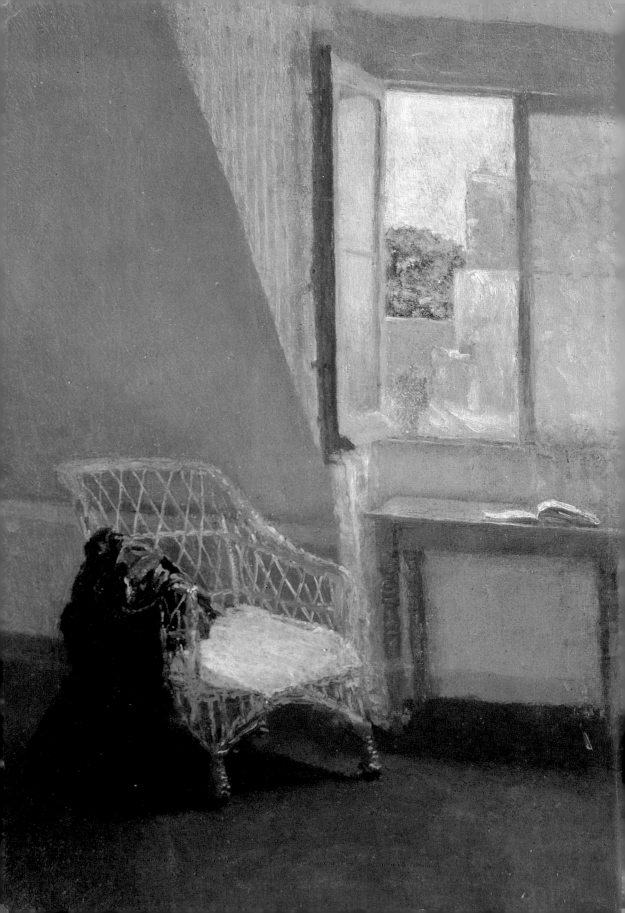

GWEN JOHN

Alicia Foster

British Artists

Tate Gallery Publishing

For Stephen Cass

Acknowledgements
My thanks to Deborah Cherry and to
Richard Thomson. Alain Beausire and
Odile Aumigny of the Musée Rodin,
Ceridwen Lloyd-Morgan at the National
Library of Wales, and Guy Francois and
Françoise Bouché of the Bon Marché were
all generous with their help. Thanks also
to Cecily Langdale and Michael Holroyd.
At the Tate Gallery, my gratitude to
Richard Humphreys, and to Celia Clear,
Sarah Derry and Susan Lawrie at Tate
Gallery Publishing.

Cover: *Self-Portrait c.*1899 (detail, fig.5)

Frontispiece: *A Corner of the Artist's Room in
Paris (with Open Window) c.*1907–9
(detail, fig.36)

Back cover: *Nude Girl* 1909–10 (fig.28)

Published by order of the Trustees
of the Tate Gallery by
Tate Gallery Publishing Ltd
Millbank, London SW1P 4RG

ISBN 1 85437 283 1

A catalogue record for this book is available
from the British Library

Cover designed by Slatter-Anderson, London

Book designed by James Shurmer

Printed in Hong Kong by South Seas
International Press Ltd

Measurements are given in centimetres,
height before width, followed by inches in
brackets

CONTENTS

INTRODUCTION

Gwen John began her training as an artist in London in 1895 when she enrolled at the Slade School of Fine Art. From 1904 until her death in 1939 she spent most of her time living and working in Paris. Although she chose to make her career in the two capitals during vibrant periods in their histories, she has often been represented as a recluse, uninvolved in the society and culture of her time. The subject of much of Gwen John's work, a female figure in an interior, has been interpreted by reference to her supposedly withdrawn character, as a beautiful expression of a solitary life.

The idea of the artist as a recluse was a powerful cultural image during the early twentieth century, and still resonates today. During this period critics who revered Cézanne as the most important figure in modern art gave great emphasis to accounts of his personality, creating a picture of a misanthrope who hated human contact. The earliest significant critical pieces on Gwen John, written in the mid-1920s, represent her as a similarly withdrawn figure. However, there is a difference of effect between the representation of male and female artists in such terms. Cézanne may be described as a solitary and strange individual, but his work is seen as a significant part of the history of modern art, while Gwen John's art has usually been perceived as being just as isolated as her life. Her moves to London and then to Paris have been interpreted as symptomatic of a search for exile despite the fact that during the late Victorian period middle-class women began to enter higher education, many leaving their families and living independently in order to have the time and space to pursue professional careers. Both at the Slade, and later in the Montparnasse area of Paris, Gwen John was part of a group of women who were training and working as artists. The lack of attention paid to these women in many of the accounts of this period and these locations in cultural history has contributed to Gwen John's reclusive image. Moreover, although Gwen John has been documented as having been interested in the work of artists who are now considered significant, from Cézanne to the Futurists, and as having met some important figures in the art world of the period, she has still often been represented as an isolated figure.

If we look at how Gwen John's image has been constructed we can allow for the possibility of other readings. Critical prominence has been given to those aspects of Gwen John's self-representation which seem to fit the picture of her as a lifelong recluse. Perhaps the best known is her statement of her 'desire for a more interior life' which has come to be seen as a distillation of the unique essence of her character and work. Gwen John used the phrase in a letter of 1912 to one of her closest friends, Ursula

Tyrwhitt, a fellow artist who had trained with her at the Slade, and to whom she was bemoaning the prospect of a family visit and its disruptive effect. In another such letter she wrote: 'I think if we are to do beautiful pictures we ought to be free from family conventions & ties.' Gwen John's letters to Ursula Tyrwhitt are also full of invitations to stay and work with her in Paris. Reading about her desire for an 'interior life' in this context changes its interpretation. Rather than suggesting a peculiar longing for total exile from all human contact, her statement seems to represent an artist's need to separate herself from family life, and to have some congenial company instead, in order to meet the demands of her art.

Another layer of meaning for the phrase 'interior life' is suggested when we look at early twentieth-century writing on art. In his 1909 account of the development of modern French art from the period of Gauguin and van Gogh, Maurice Denis (an artist whom Gwen John is known to have admired) argued that artists should seek to express the human 'vie intérieure' through their work. Gwen John's writings from later in her life, following her conversion to Catholicism, refer to being alone as being 'nearer God', to her art and religion being her whole existence, and to her desire to be a saint. Again, these statements can be interpreted in the light

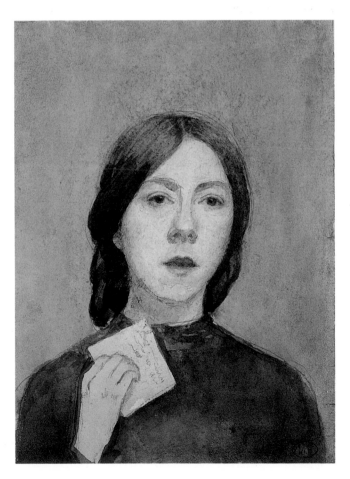

1 *Autoportrait à la lettre*
*c.*1907–9
Watercolour and pencil on paper
22.3 × 16.1 (8¼ × 6½)
Musée Rodin, Paris

of ideas, current amongst artists and in contemporary critical writing, which suggested links between art and Catholicism, and expounded the notion of the artist as a religious figure.

This is not to argue that Gwen John never desired solitude, but that her writings dealing with this subject ought to be seen in their different contexts, and should not be emphasised to the exclusion of other letters in which she represented herself differently. The artist's surviving correspondence sometimes represents her enjoying life in the city both alone and in company. In a letter of 1904 to Ursula Tyrwhitt, she gave an account of a night-time walk in Paris with another friend, Dorelia McNeill: 'We have been out for a walk it is quite late, the sky is a deep blue with some great clouds, the Luxembourg gardens looked so beautiful with no soul there so quiet and peaceful and the trees are so beautiful down the streets occasionally lit by a lamp I sometimes sleep in the gardens in a little copse of trees.' Other letters represent her pleasure in her social life as a successful artist. Writing of showing her work at the Parisian Salons in the 1920s, she enthused: 'It is amusing to have things in them and to go and see them at the vernissage and to give vernissage cards to friends and to make rendez-vous!' The idea that Gwen John shunned public attention for herself and her work throughout her life is unsettled by such writings. Among her papers is a copy which she made in French of a quotation from Oscar Wilde's *The Picture of Dorian Gray*. The part which caught her eye, and which she noted down, is Lord Henry Wotton's advice to the artist Basil Hallward to exhibit his work: 'there is only one thing in the world worse than being talked about, and that is not being talked about.'

Our understanding of Gwen John as a solitary figure relies, then, upon a selective reading of her papers, but it also requires that her writings, and her art, are seen as representing the unmediated truth about her innermost self and thoughts. The watercolour *Autoportrait à la lettre* (fig. 1) could be interpreted as confirming this assumption. It was given by Gwen John to the sculptor Auguste Rodin, whose model and lover she became in the 1900s. The artist painted herself with a look of concentration, her mouth slightly open as if she is about to speak, and holding up a letter. The picture unites Gwen John's speech, her correspondence and her art, and seems to suggest that they are all direct expressions of herself. However, during the same period in which she painted this picture, Gwen John was writing a series of letters which she sent to Auguste Rodin but addressed to an imaginary sister, and signed 'Marie'. In some of these letters 'Marie' states that she is an artist's model, not an artist. Marie confides in her 'sister', but should we read these letters as transparent evidence of Gwen John's thoughts and feelings? The idea that an artist's subjectivity is fixed and coherent and directly mirrored in her letters and work clearly does not explain shifts in self-representation such as that between the professional artist of Gwen John's letters to Ursula Tyrwhitt, and 'Marie' the model writing to her 'sister'.

Theories of identity which more usefully account for such changes and discrepancies have been developed in recent years. Drawing on psycho-

analytic theory, some cultural critics have identified a gap between the historical individual and their representation. Rather than *reflecting* a pre-existent subjectivity, an individual's letters and art are understood as *constructing* identities from a choice of different historical and cultural images and values which can be used and manipulated to fulfil certain needs and desires. The choices made are not predetermined, but neither are they limitless, being shaped by the individual's sex, their race and class, and the historical period in which she or he lived. So, instead of reading Gwen John's correspondence as empirical evidence of her reclusive nature and ignoring those letters which contradict this idea, we can identify the different versions of herself which Gwen John created for different correspondents, and look at how she chose to represent herself within the wider historical context of the representation of femininity in letters and in literature.

This approach has implications for understanding Gwen John's art as part of the culture of her time. As an artist her changing technique, from painting in layered glazes to the mosaic-like brush strokes of paint in her later work, her method of painting in series and the importance of drawing throughout her career can be mapped against wider developments in art practice. Her long career as a painter of female sitters took place during a historical period in which there were particular and often conflicting ideas about the role of women, which were played out in the cultural representation of different feminine types. From 1890s London in which the New Woman had become a media symbol of a search for independent lives and careers, to the contrasting images of Catholic womanhood and the flapper in the post-war Paris of the 1920s, the art of the time was filled with images of women, particularly in the French capital, where a variety of new techniques and styles was used to represent femininity. This is not to argue that because of her sex Gwen John's images of women are necessarily progressive, or that she followed the representational strategies used by the leaders of Parisian modern art. But if we acknowledge Gwen John's presence in London and Paris, and her awareness of what was happening in their respective art worlds, her paintings of women become more significant. Rather than being interpreted as involuntary expressions of her inner self, we can examine the choices Gwen John made as a woman artist when she painted and drew women in certain ways. The representation of the interior, and particularly the relationship between women and interior space which was such an important theme in Gwen John's work, far from being an idiosyncrasy, was a key subject in the cultural arena. The interior, sometimes empty, sometimes occupied, had become a significant subject for artists in the late nineteenth and early twentieth centuries. In London a critic wrote of 'interior fever' sweeping the New English Art Club (NEAC) where Gwen John first exhibited her work, and in Paris the *Peintres d'Intérieurs* had their first group exhibition. Artists from the Camden Town Group in London to Bonnard and Vuillard in France created diverse images of rooms and their inhabitants, and we have to ask how Gwen John's work relates to this period in the history of art.

I
LONDON AND THE SLADE

Gwen John was a Slade student from 1895 to 1898, a time which is considered a golden era in the history of the school. During the late 1890s the Slade even ran its own magazine, the *Quarto*, to chronicle the work of students and tutors. Descriptions of the importance of this period feature to this day in the biographies of those Slade students who became successful artists, and in histories of British art education which discuss the school's influence. Frederick Brown and his colleagues Henry Tonks and Philip Wilson Steer are credited with making rigorous drawing from the life-model, as practised in the Parisian ateliers, the foundation of their teaching. Having mastered the basics of line and proportion drawing from casts of classical sculpture, most Slade students moved quickly on to the life-room. By contrast the Royal Academy still taught the laborious stippling drawing technique, and students worked in the Antique Room for much longer. The progressive reputation of Slade teaching, and the fact that both male and female students were allowed to work from the life-model, explains its attraction to the large numbers of women who attended during the late 1890s (they made up approximately two-thirds of the students at this time). Most of these women would have been from the middle or upper classes as the Slade was fee-paying. Gwen John was supported financially by her father, a solicitor, during her studentship, and the modest but regular private income which she received in later years from her mother's estate must also have helped to give her the opportunity to pursue her artistic career. However, despite the large numbers of women among Gwen John's student contemporaries, the Slade is often represented as an art school which produced several important male artists, and also happened to be populated by talented and attractive females. As early as 1907 a book was published on the alumni of the 1890s and early 1900s, written by an ex-student, in which women made up only a quarter of the artists mentioned.

There have been many colourful accounts of the flamboyant appearance, adventures and work of the male students of the 1890s. The belief that such masculine bravado was an essential characteristic of the artist, and the assumption that late-Victorian ladies were, by contrast, confined within a separate sphere of decorum and respectability, helps to explain the comparative lack of attention which has been paid to the women students. Certainly a well-known idea of artistic identity of the period, the bohemian image famously cultivated by Gwen John's brother, Augustus, also a Slade student, did not lend itself to use by women. Tales of the bohemian life of artistic circles on the Parisian left-bank fascinated late nineteenth-century

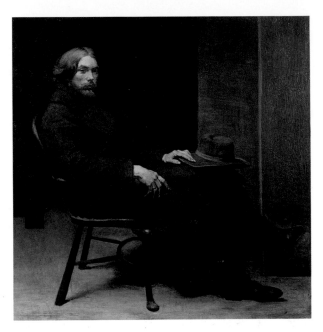

readers. George du Maurier's novel *Trilby*, which was a huge success on its publication in 1894, told the story of a group of male art students and their eponymous model (fig.2). In the sexually polarised art world represented in such literature women served as models, muses and mistresses, but not as artists themselves, and the influence of such ideas can be seen at the Slade, where pupils nicknamed their tutors after the students in the novel. Tellingly, William Orpen's portrait of Augustus John, painted just after they finished their art training, shows the sitter in bohemian dress, the corner of a bed behind him (fig.3). Nevertheless it is important to realise that women were not necessarily held back by definitions of artistic genius as an attribute tied to male sexuality and to the image of the bohemian. Rather, going to art school gave women the opportunity to work and socialise together and to make their own representations, which should be seen in the light of their different position as students.

Women students were subject to late nineteenth-century ideas of femininity. Ideas of sexual difference were manifested at the Slade in the segregation of male and female students into separate rooms for the most important aspect of Slade training, life drawing. The physical organisation of sexual difference underpinned the different position of women students in relation to contemporary debates about the viewing and representation of the female nude. This is evident in accounts of male and female student life. While Augustus John and William Orpen were represented as both drawing with great panache and having affairs with models, women's relationships with the female nude were more complicated. The journal of a contemporary of Gwen John's, Wyn George, relates an ongoing process of trying to make sense of looking at and drawing the female nude. She found

4 Edna Waugh,
*The Rape of the
Sabine Women*
c.1897
Watercolour
Destroyed in the
Second World War

herself unable to understand why her tutor, Henry Tonks, should choose to paint *A Lady Undressing*, yet also declared herself 'sick' of paintings of 'Grecian girls and marble' by the first Slade professor, Edward Poynter. George was rejecting two of the central discourses of the nude in late Victorian art, the representation of the subject influenced by the work of Degas, and the neo-classicism of Poynter, Alma-Tadema and Leighton. In order to be able to work in the life-room George was careful to maintain her own distance from the model, always being aware of the class difference of the naked woman before her, and she married this to a belief that her purpose in life drawing was to capture the beauty of nature. Other women developed different ways of dealing with the female nude. Another student, Edna Waugh, entered a watercolour for a Slade competition for the best representation of the classical story of the rape of the Sabine women and, according to a later memoir, used herself as a model for the composition (fig.4). The respectability of a middle-class student such as Waugh would have been jeopardised if it had been acknowledged at the time that she had worked from studies of her own body, rather than from those of an anonymous working-class model. Despite the complexity of their situation, women had some success at the Slade. Edna Waugh's *Rape of the Sabine Women* was awarded a prize and reproduced in the *Quarto*, and Gwen John herself won prizes for figure drawing and figure composition.

Gwen John and her Slade contemporaries were part of a generation of women for whom the struggle for education and work, and an increasing sense of freedom and confidence, were epitomised by the figure of the New Woman. 'New Woman' was a label attached to a type of female character who began to appear in novels and plays of the 1890s, who fought for the development of her own mind and talents, and for some degree of autonomy. The perception of this model of femininity as a threat to male privilege and to social stability led to satirical cartoons and dramas in which the New Woman was represented among piles of modern novels, with dishevelled hair and wearing tailor-made separates, an image which, as Viv Gardner has pointed out, was both a reflection and a parody of the tastes and appearance of many independent single women. For numbers of

5 *Self-Portrait*
c.1899
Oil on canvas
61 × 37.7
(24 × 14¾)
National Portrait
Gallery, London

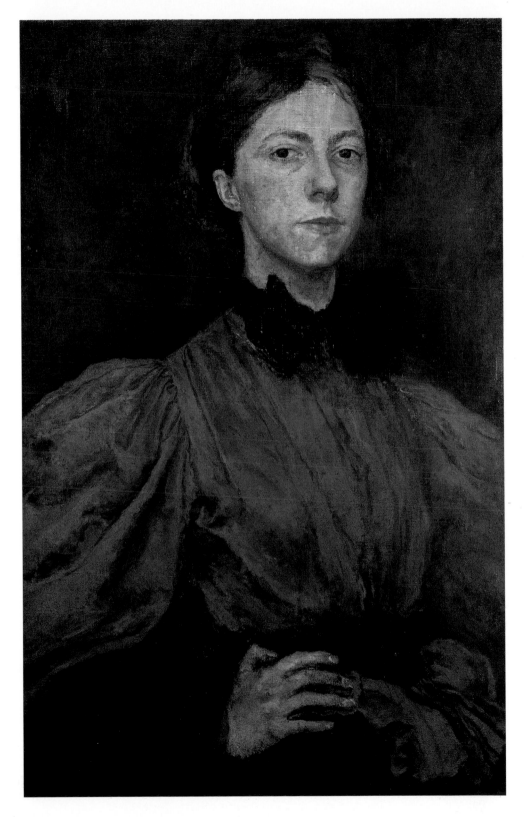

women at the Slade, including Gwen John, student life meant a move away from the family home, and art school training also required them to travel around the city, visiting galleries and exhibitions. The relatively new presence of women students was signalled at University College London, the institution of which the Slade was a part, by the foundation of a Women's Union in 1897. Many women Slade students joined the University College Literary Society, and the Slade magazine included work by Evelyn Sharp, who wrote about modern women and was also published in *The Yellow Book*, the illustrated quarterly whose artistic editor was Aubrey Beardsley.

Because of their new visibility at the Slade and in the city, for these women appearance became an important means of signalling their modernity and place in the art world. Wyn George's journal mentions the lack of corsets and untidy hair of her female contemporaries, linking them to the independent New Woman rather than conventional decorous femininity. Edna Waugh wrote of wearing an overall with a coral necklace, combining a practical working garment with jewellery which was recognisably artistic. It is not surprising that making portraits of themselves and each other also became a significant form of representation. The first work Gwen John ever exhibited, after she had completed her art training, was a painting which she titled *Portrait of the Artist* and showed in the Spring of 1900 at the New English Art Club, an exhibiting organisation dominated by the Slade tutors. *Portrait of the Artist* is almost certainly the painting now known as *Self-Portrait*, in the collection of the National Portrait Gallery (fig. 5). A reviewer of the time commented that the painting had some 'notable qualities', and it is an image of assurance, but what is most striking about it is the way Gwen John used and brought together particular codes of representation in order to create an image of artistic identity which is completely of its time.

Looking at the composition and pose of the figure in Gwen John's *Self-Portrait* it becomes apparent that the artist knew the portraits of painters such as Rembrandt, Hals and Van Dyck. Visiting galleries and copying works in their collections was part of Slade training, and there are records of Gwen John's registration as a copyist at the National Gallery in London. It was not only Slade students who were interested in the creative practice of working from old masters during the 1890s. There was widespread interest in these artists, and well-known painters such as John Singer Sargent and James McNeill Whistler reworked old master portrait styles. But there were complex social

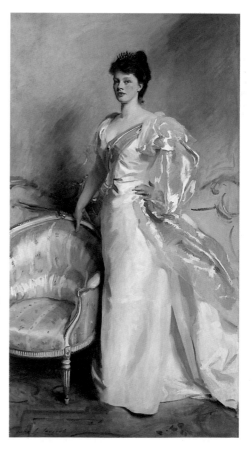

6 John Singer Sargent, *Mrs George Swinton* 1897
Oil on canvas
228.6 × 124.5
(90 × 49)
Art Institute of Chicago, Wirt D. Walker Collection

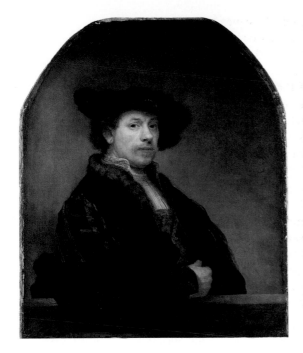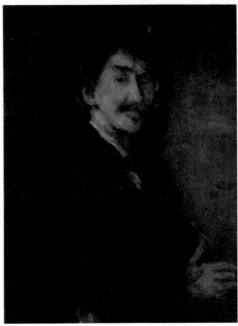

and political investments in the revival of historical portraiture. The representation of women in this genre emphasised beauty and social position, often showing the sitters full-length and wearing sumptuous costumes in opulent interiors, so creating an image of them as a spectacular part of a long and illustrious familial and cultural lineage, as in Sargent's 1897 portrait *Mrs George Swinton* (fig.6). While Gwen John's painting clearly makes use of the conventions of historical revival portraiture, it creates an image of femininity very different from the decorative vision which is Sargent's sitter.

The most obvious difference is the size of Gwen John's painting. Sargent's work was meant for the huge rooms of his wealthy patrons, while Gwen John's self-portrait seems to follow the aims of many of the NEAC artists who were noted by a critic of 1901 as making paintings on a scale 'for which everybody has room and which do not look hopelessly out of place in the small houses with which most people have to content themselves'. Rather than taking up the historical revivalist conventions for representing women, and creating an image of herself as a full-length spectacle with a sweeping gown, the artist painted herself as a half-length figure with a level gaze and an air of spirited confidence. The position of her right arm emphasises the full curve of her sleeve, and the fabric over her forearm draws attention to her hand. Although this composition does not include obvious signs of artistic production, such as palette and brushes, it still signified artistic identity, as similar formats and poses had been used by a long line of male artists to create their self portraits, notably Rembrandt, whose *Self-Portrait aged Thirty-Four* of 1640 (fig.7) Gwen John is likely to have seen in the National Gallery. From the 1870s to the 1890s this composition was

reworked by Whistler in a series of self-portraits, including *Gold and Brown* of *c.*1896–8 (fig.8). Whistler was the contemporary artist perhaps most admired by Slade tutors and students, and, having left the Slade, Gwen John studied at his Parisian Académie. That Whistler had chosen this composition in order to represent his power and prestige as an artist is affirmed by the fact that he painted *Gold and Brown* for the first exhibition of the International Society of Sculptors, Painters and Gravers, of which he was president, which was held in London in 1898. Whistler's reworking of the old masters used a dark and close tonal range and subdued colour to create an image of authority and artistic identity. Although Gwen John's *Self-Portrait* can be understood within the context of historical revivalist portraiture, it is Whistler's reworking of old master self-portraits, rather than Sargent's dazzling paintings of women, that Gwen John's painting follows.

Using a composition which invoked a long tradition of male artists' self-representation, Gwen John overlaid an image of her own face, and of a particular costume which was crucial to her creation of an image of herself as a powerful woman artist. Her full sleeves were both fashionable at the time and reminiscent of Rembrandt's costume. The practical separate blouse and skirt and the large and dashing bow tie were modern innovations in women's dress and the New Woman was often characterised wearing similar clothes. This style of costume was used in other images of women artists, such as Flora Reid's self-portrait which was reproduced in 1895 in a *Magazine of Art* feature, 'Some Noted Women Painters'. If the painting is the *Portrait of the Artist* with which Gwen John made her exhibiting debut at the NEAC in 1900, its importance as a statement of artistic identity becomes clearer. As was usual at the NEAC, works by women artists were in the minority, and among the exhibits was William Orpen's imposing portrait of Augustus John. Showing a portrait of a modern woman which claimed a place for her among great artists provided a feminine alternative to images and ideas of male artistic genius.

Although the self-portrait Gwen John painted in 1902 (fig.9) seems at first glance to represent a very different version of herself to her painting of *c.*1899, its basis in turn-of-the-century developments in the understanding and representation of femininity is similar to the earlier picture. As Deborah Silverman argues, while men had often been portrayed as individuals with psychological lives, the representation of women in such terms, rather than as merely decorative and modish, became noticeable during the era of the New Woman, and developed out of the ideas of feminine autonomy surrounding her. The novels of writers such as Sarah Grand, and Ibsen's plays, particularly *A Doll's House*, featured intelligent heroines who sought personal fulfilment beyond familial roles. So while Gwen John's earlier painting can be understood as representing the New Woman as artist, her later self-portrait creates an image of a self-contained woman of psychological depth. The plain background, also used in the earlier self-portrait, focuses the viewer's attention completely on the figure. The meticulous method of painting in oil glazes which Gwen John used for

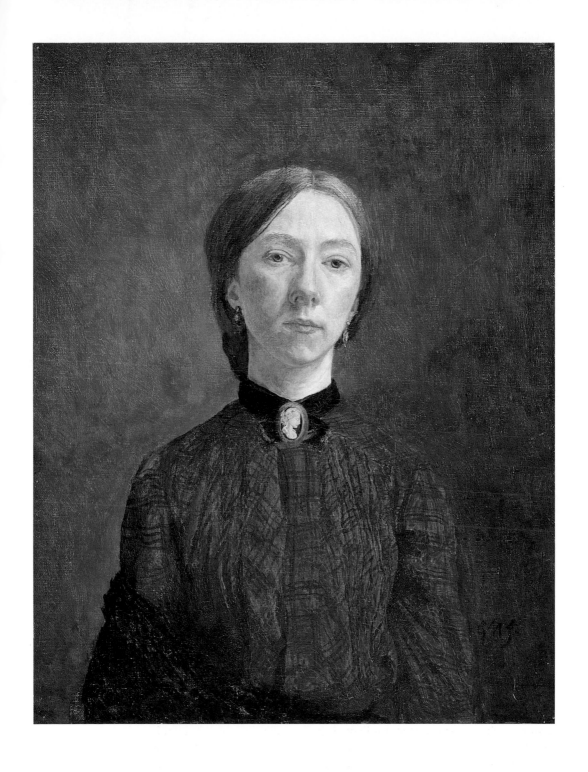

9 Gwen John. *Self-Portrait* 1902 Oil on canvas 44.8 × 34.9 ($17\frac{1}{4} \times 13\frac{1}{4}$)
Tate Gallery

this portrait was based on research into the techniques of the old masters and enhances the feeling of sharp and dispassionate scrutiny.

Another similarity to the previous self-portrait is the importance of dress in the painting. The shape of the sleeves reflects the change in fashion which had taken place in the period since the earlier portrait, and indicates Gwen John's awareness of contemporary modes. But the clothes and accessories in the portrait are not high fashion of the period. The neck-ribbon, shawl and hairstyle seem mid-Victorian, and suggest a playing around with style and representation and a refusal to conform, which is underlined by the carefully painted unruly strand escaping from the otherwise neat hair. The cameo brooch the artist wears is also significant. Cameos of single female heads were popular in the mid-Victorian period, while the height of fashion in the 1900s were the magnificent jewels worn by society ladies. Rather than being the preserve of the wealthy, the cameo was less exclusive jewellery and also had strong cultural connotations. It referred to classical civilisation, and so had often been worn by women in artistic circles. William Holman Hunt (fig.10) painted both his first and second wives wearing the same cameo brooch, and Edward Poynter designed cameo jewellery for his wife. The female heads featured on cameos often represented ancient mythological figures, a popular choice being Minerva, Roman goddess of intellectual and cultural activity who was invoked by those who wished to distinguish themselves in the arts. Gwen John's self-portrait was shown at an exhibition of past and present students' work organised by the Slade tutors in 1902, where the painting technique she used, the representation of femininity and the allusions to artistic dress and classical culture are likely to have been appreciated, and it was bought by Frederick Brown. The differences between it and her earlier painting can be interpreted as Gwen John's exploration of more than one type of self-image, understandable when we locate her as part of a group of women at the Slade whose training gave them the power to represent themselves.

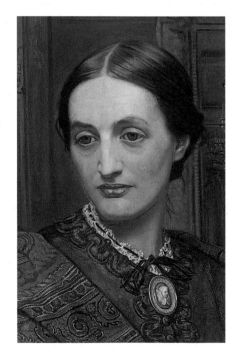

10 William Holman Hunt,
Fanny Holman Hunt c.1866–8
(detail)
Oil on canvas 104 × 73 (41 × 28¼)
Toledo Museum of Art, Toledo,
Ohio; Purchased with funds from
the Libbey Endowment, Gift of
Edward Drummond Libbey

2

PARIS

After leaving the Slade Gwen John travelled to Paris. A stay in the French capital training in one of its many ateliers was considered an essential part of an artist's education; the Slade tutors Brown and Steer had themselves both studied there. Travel also gave artists the opportunity of seeing the great European art collections at first hand, extremely important in an age in which reproductions were not sophisticated. For women particularly, travel could mean greater independence, living in a foreign country and being part of a group based on communality of work. British art journals recommended Paris as a centre of art study, describing the great variety of nationalities to be found working in the ateliers there. During the late nine-teenth and early twentieth centuries these articles began to be addressed to prospective female students, and writers in women's magazines began to discuss the relative merits of the different studios (fig.11). By 1909 *A Woman's Guide to Paris* had been published. Its author, Alice Ivimy, stated that she had written in response to the ever-increasing tide of women visiting the French capital alone or with other women, in order to provide them with practical advice on independent life in the city. On Gwen John's first visit to Paris, which took place from the autumn of 1898 to early 1899, she was accompanied by two of her Slade friends, Ida Nettleship and Gwen Salmond. Their stay coincided with the opening of a

11 *L'Académie Colarossi Night Class* illustrated in the *Lady's Realm*, vol.8, May–October 1900

new studio by Whistler, the Académie Carmen, and all three women seem to have studied Whistler's methodical tonal painting technique there. Ida Nettleship's letters of this period create a picture of the friends enjoying life in the 'Capitale de l'Art', working at Whistler's Académie, visiting the Louvre and painting in their shared apartment in Montparnasse.

Montparnasse was known for its artistic community and its numerous studios. Also, from the 1890s to the 1910s it was a changing *arrondissement*. As part of the continuing transformation of Paris into the city of spectacle which had been planned by Baron Haussmann, Napoleon III's minister, the Boulevard Raspail was being built, cutting a swathe through the dense networks of artist's studios. Montparnasse was also home to sites of leisure and pleasure such as the Jardin and Musée du Luxembourg and, on its northern side, the first of the *grands magasins* (department stores), the Bon Marché. Bon Marché catalogues promoted the latest fashions for women (fig.12), and the shop was represented as a world created for female customers in advertisements and in cultural images. Zola's novel *Au bonheur des dames* published in 1883 was modelled on the foundation and development of the Bon Marché and the new form of retail it ushered in. Mouret, the owner of the shop in Zola's novel, spelt out his business technique: 'Of supreme importance … was the exploitation of Woman … It was Woman the shops were competing for so fiercely, it was Woman they were continually snaring with their bargains, after dazing her with their displays.'

12 Cover of a Bon Marché catalogue from 1904.

Women were often represented as one of the city sights, a favourite subject for artists, seduced by and displaying new fashions. But Paris had also become a city in which large numbers of women were themselves working as artists and were able to intervene in the spectacle. Gwen John's correspondence of the 1900s discusses current modes and shopping at the Bon Marché, and represents women artists not just following fashion through buying ready-to-wear clothes but also designing and making clothes themselves in order to dress up for life in the Parisian art world. Her painting, *Interior with Figures*, of her two friends Ida Nettleship and Gwen Salmond, can be interpreted in this light as evidence of the artist's interest in reworking the image of chic Parisian femininity during her first visit to the French capital (fig.13). During their stay in Montparnasse, Ida Nettleship was researching and buying fashion plates of the 1850s for her mother, the theatrical costumier Ada Nettleship. She recommended the illustrations in the book

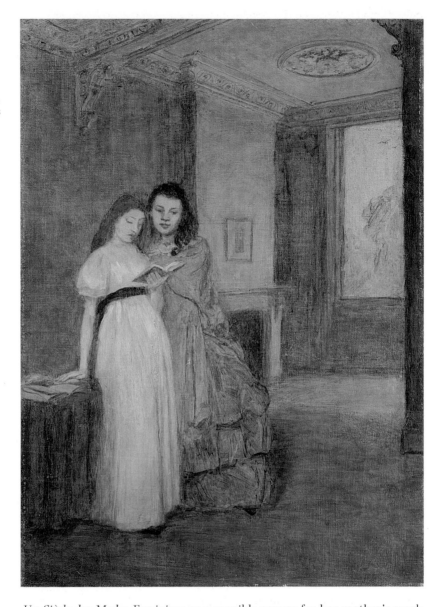

13 *Interior with Figures c.* 1898–9
Oil on canvas
46 × 33.4
(18¼ × 13¼)
National Gallery of
Victoria, Melbourne,
Australia. Gift of Mrs
C.H. Collins-Baker
1947

Un Siècle des Modes Feminines as a possible source for her mother's work, and commented: 'We want to keep these prints I am sending you, they are so pretty. The one of the two ladies only indoors is not dated I thought it looked about right ... Gwen S. and J. are painting me and we are all three painting Gwen John ... Gwen J. is copying one of those fair dames in the fashion plates.'

The fashion plate had been eulogised as an art form which most accurately expressed each era's idea of modernity by the French poet and critic Charles Baudelaire in his essay *The Painter of Modern Life* (1863), and both Cézanne and Berthe Morisot had used fashion plates in their work. Mid-nineteenth-century fashion illustrations usually featured two women with similar faces which exemplified the current idea of beauty. They were

shown full-length, wearing uniformly modern clothes and standing in luxurious interiors (fig.14). Gwen John used the basic format of fashion illustration, but she painted two very different individuals dressed in costumes which were definitely not *à la mode* during the 1890s. Gwen Salmond, the figure on the left, is wearing a high-waisted gown with full sleeves. Variations on this style of aesthetic dress had been created and worn by women in the art world for several decades. However, Ida Nettleship is shown in the fashionable costume of the 1850s, with full flounced skirt and shawl. The room the women stand in is not the comfortable and ornate interior of a fashion illustration, but is stripped bare of all but the signs of culture – books and a picture on the wall. Painting women wearing mid-Victorian dress in austerely furnished interiors was very much of the moment among the artists who exhibited at the NEAC, where it is likely that Gwen John showed *Interior with Figures* in 1902. Critics in that year noticed a vogue for transforming the simple and old-fashioned into art, which they described as a development from Whistler's work and labelled 'the modern antique'. Gwen John's juxtaposition of two styles of costume from different eras means that, although her painting does indicate her awareness of contemporary developments in British art, it does not strictly follow the trend described by the NEAC critics. Neither can it be understood as costume painting, a representation of a historical event or period. Rather, *Interior with Figures* creates an image of women whose appearance was not controlled by the dictates of the couturiers, but was shaped instead by their own knowledge and manipulation of the significance of dress.

15 *The Student* 1903–4 Oil on canvas 56.1 × 33 (22¼ × 13) Manchester City Art Galleries

After spending a brief holiday in France in 1900, Gwen John returned again with her friend Dorelia McNeill in the autumn of 1903. The two women set out on a walking tour, taking their art equipment with them, and intending to travel as far as Rome. It is likely that Gwen John's intention was to take advantage of the free tuition available for artists at the British Academy in Rome, in addition to seeing the rich collections of art there. In the event they got as far as Toulouse, earning their living along the way by selling portrait sketches. According to Dorelia McNeill's reminiscence of the journey, Gwen John 'always managed to look elegant … She wasn't at all careless of her appearance; in fact, rather vain. She also much appreciated the good food and wine to be had in that part of France'. Toulouse itself was known as a lively and artistic city, and here Gwen John made a series of portraits of her companion, which included *The Student* (fig.15). The artist

14 The fashion of 1852 illustrated in G. Charpentier and E. Fasquelle (eds.), *Un Siècle des Modes Feminines 1794–1894*, published in Paris in 1896.

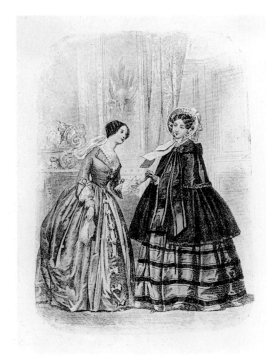

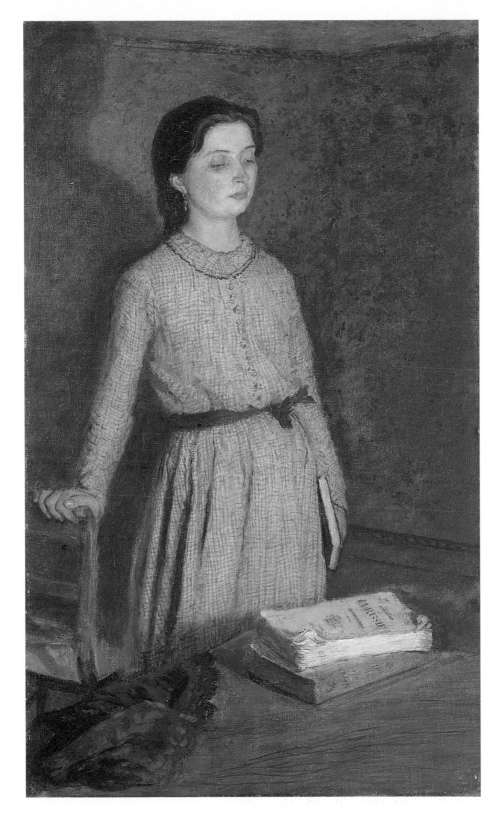

titled the painting *L'Étudiante* for exhibition at the NEAC in 1909, locating it in France and evoking the two women's life of travel and work. This painting, and the similar *Dorelia by Lamplight, at Toulouse*, which Gwen John originally titled *Reading*, create an image of the sitter which is very different to the well-known vision of Dorelia as a beautiful bohemian in the work of Augustus John. She is represented in his art as an object of desire and mother figure, wearing vivid and striking clothes and often surrounded by children. In Gwen John's two paintings of Dorelia with books, she is dressed soberly and the emphasis, created by both the titles and the poses, is on the intellectual life of their model. It has been suggested by Ceridwen Lloyd Morgan that the book lying on the table in both paintings, titled *La Russie*, is likely to be *La Russie en 1839* by the Marquis du Custine, a reference perhaps to the progressive taste for French and Russian literature which was shared by Gwen John and her women friends. In her memoir, *Self-Portrait of an Artist*, another ex-Slade student, Lady Kathleen Scott, recalled her first visit to France in 1901 when, staying in Paris in order to train at an atelier, she read 'French translations, only half understood, of Dostoeivski, Casanova or some such, in an excited determination to understand the wild world I lived in'. Gwen John's surviving book collection contains an 1884 French translation of Dostoevsky's *The Idiot* and an 1888 copy of Zola's *La Terre*, in addition to later editions of works by Chekhov and Turgenev in French. If Dorelia is about to study from *La Russie en 1839* the choice is especially evocative as the marquis's book was travel writing, recording his impressions of his journey in letter form.

Gwen John left Toulouse and travelled to Paris with Dorelia in February 1904. On her return to the city she went back to Montparnasse. After staying briefly a couple of streets away from the apartment she had shared in the late 1890s, and then at the home of an artist friend, Mary Constance Lloyd, she took a room of her own at 7 rue St Placide, opposite the Bon Marché. She stayed there until her move in 1907 to an attic room at 87 rue du Cherche-Midi. Her last address in Montparnasse was 6 rue de l'Ouest, which Mary Taubman has identified as looking out onto the Cour des Miracles, a dense network of artist's studios. In 1911 Gwen John took rooms in Meudon on the outskirts of Paris, maintaining 6 rue de l'Ouest as a studio and travelling into the city to work until 1918. Meudon was wooded, with fine views over the city. The area was home to Rodin and to other artists, and she eventually bought a studio and garden there. Her changing arrangements for living and working, from rented room in Paris to her own studio in Meudon, reflect her shift in status, and are a progression which a successful artist would have been expected to make.

For British artists, association with France was significant when it came to establishing a professional reputation through exhibiting, as well as for training and working. French art was seen as leading the way by many of the members and exhibitors at the NEAC. After all, one of the names proposed at the inception of the organisation in 1886 had been the Society of Anglo-French Artists. This accounts for Gwen John's decision to show her work in London at the NEAC during her early years in Paris, and for

the French titles she gave some of her art. The use of French titles was common practice among NEAC artists, some of whom showed images of well-known Parisian areas, such as Ursula Tyrwhitt's two views of the Jardin du Luxembourg exhibited in 1910.

Another aspect of the NEAC which contextualises Gwen John's work is the status of drawing at its exhibitions. As drawing had been the foundation of Slade teaching, it is not surprising that it should become increasingly important at NEAC shows, given the authority of the Slade tutors within the organisation. In 1907 a critic writing in the *Studio* noted that among NEAC artists 'Independent existence as an art is thus almost again restored to drawing, after a period of eclipse'. Gwen John's drawings are a significant part of her work, and she exhibited numbers of them at the NEAC, and at important exhibitions later in her career. Her letters to Ursula Tyrwhitt discuss the importance of exhibiting, and specifically of showing her art at the NEAC. This was not only due to financial necessity, although the letters do mention sending work specifically in order to sell it. Gwen John's letters also stress her need for an audience for her art. She requested reports from Ursula Tyrwhitt on how her pictures had been hung and how they looked *in situ*, and on one occasion sent a painting she had already sold to be exhibited at the NEAC to find out 'what it appeared like to people' before it was sent to its owner.

16 Gwen John and
John Quinn in Paris,
1923
Private Collection

25

Occasionally Gwen John wrote of being unhappy with the NEAC. The organisation did discriminate against women artists, who were greatly outnumbered in its exhibitions and were not represented on its committee and selecting jury, perhaps explaining why she wrote in a letter to Ursula Tyrwhitt, 'I hope our pictures will hang together!! I feel so lonely in the New English!' In 1911, she exhibited at the NEAC for the last time. Her decision to stop sending her work there can be seen as part of a wider dissatisfaction with the organisation, which by 1910 was being criticised as conservative. A belief among some critics that modern art was not being adequately promoted or seen in Britain led to the foundation of the Contemporary Art Society in 1910, whose mandate was to buy modern art for the nation. As early as 1911 a member of the CAS bought two of Gwen John's paintings and gave them to the society, who in turn presented them to the Tate Gallery in 1917. Also, in the summer of 1910 Gwen John gained an important new patron, the American art collector John Quinn. Quinn bought most of the work Gwen John sold until his death in 1924, and he also solicited her opinion on the art exhibited in Paris, and on the pieces he bought there (fig.16). Gwen John received financial support from Quinn, but his patronage was also important in that he introduced her work to American audiences as part of the modern movement, including it in the seminal *Armory Show* of 1913, and the exhibition *Seven English Modernists* of 1922, among others. As part of his prestigious collection of modern art Gwen John's work was seen alongside pieces by Brancusi, Braque, Cézanne, Matisse, Picasso, Puvis de Chavannes, Seurat and Marie Laurencin.

Although during the 1914–18 war it was impossible for Gwen John to exhibit in London or Paris, following her Parisian debut at the Salon d'Automne in 1919 she became a distinguished figure. Jeanne Robert Foster, who was in the French capital in the early 1920s acting as Quinn's adviser on art purchases, gave this account of Gwen John's standing: 'If Marie Laurencin has an established position over here, I cannot find anyone who knows of it. We asked in three galleries, and found the clerks knew nothing of her. Miss John has never seen or heard of her. The Americans I know, painters, I mean, have never heard of her. They all knew of Miss John however, and the Salon takes all she will send them.'

Quinn's interest in Gwen John's opinion signifies how much she was considered a knowledgeable member of the Parisian art world during a particularly exciting period. The artist's letters indicate her interest in the exhibitions on show in Paris from her early days there. Writing to persuade Ursula Tyrwhitt to visit in 1904, Gwen John mentioned as an inducement a particularly fine exhibition of the *Primitifs français*, artists working from the fourteenth to the sixteenth centuries who had been influenced by Flemish and Italian masters. Her surviving correspondence refers to visits to the Louvre and also to seeing work by artists including Cézanne, Chagall, Renoir, Rouault, Rousseau and Seurat. Gwen John's opinions on contemporary art are sometimes surprising, and always indicate her awareness of what was happening in the art circles of the French capital. The first

Futurist exhibition took place at the Bernheim-Jeune Gallery in February 1912, and she commented on it in a letter to Ursula Tyrwhitt: 'There are some painters who call themselves "Futuristes" exhibiting now … They are very amusing and have great talent I think. I don't know whether it is Art. I sent Gus the cataloge [*sic*], if you see him ask him for it, some of their pictures are in it. The school of Matisse is far far behind and most academic and conventional beside them' (fig.17).

As her letters to Ursula Tyrwhitt suggest, Gwen John remained in contact with artists in Britain through her correspondence. In addition to her brother Augustus, who rapidly became a successful artist after leaving the Slade, Gwen John maintained friendships with a number of women artists, some of whom made working visits to Paris. Grilda Boughton-Leigh, who had herself studied at the Slade, and her sister Chloë, made several long visits to the French capital at different periods, during which Gwen John made three paintings and a series of drawings of Chloë. The first of these, painted around 1907, shows Chloë Boughton-Leigh sitting with what appears to be a letter in her hand. Her gaze, and the subdued colour of the painting, create an atmosphere of intensity and self-absorption (fig.18). In an era in which women wore their long hair up in bouffant coils and waves it was unusual to have a portrait painted with simply dressed loose hair. Neither does the costume the sitter is wearing follow the *belle époque* fashion for a corseted S-bend figure fussily and expensively decorated with frills and lace. The subtle fabric is similar to that worn by Dorelia in the Toulouse pictures. The plainly cut dress with its round neck and buttons to the waist, is very like the garment which women in artistic circles, particularly Dorelia herself, became well known for wearing in the 1900s. The painting was a success at the NEAC exhibition of spring 1908 where it was first shown; it was hailed by a critic as 'one of the greatest achievements in the exhibition' and Gwen John was praised for focusing on

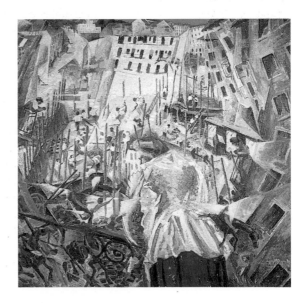

17 Umberto Boccioni,
The Street Enters the House 1911
Oil on canvas
100 × 106 (39½ × 41¾)
Sprengel Museum,
Hanover

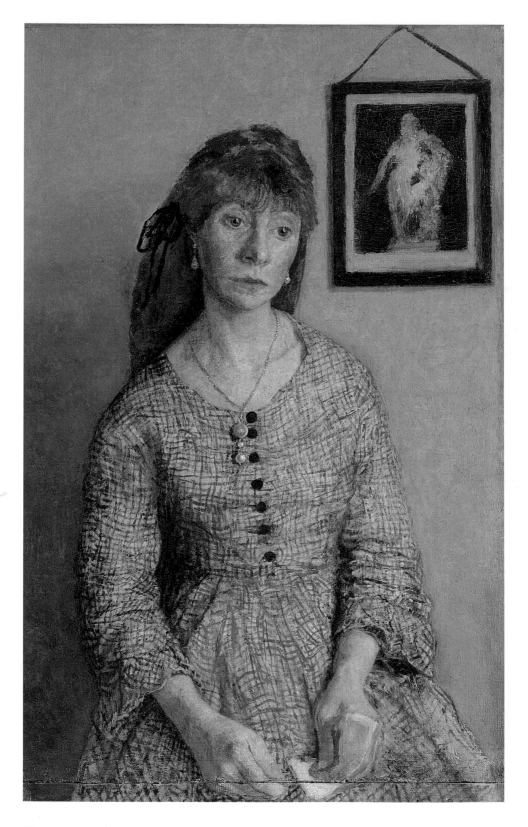

18 *Chloë Boughton-Leigh* c.1907
Oil on canvas
58.4 × 38.1
(23 × 15)
Tate Gallery

'the colour which ordinary life wears'. The expression 'ordinary life' implies a critical equation of the representation of the plain and understated with artistic worth, a taste fulfilled, in this case, by the portrait of a pensive Chloë Boughton-Leigh in her simple dress.

Gwen John also became part of artistic social circles in Paris, through her professional career and also due to the modelling work which helped to support her during her early years in the French capital. Perhaps best known is her relationship with Auguste Rodin, whom she met during her first summer in Paris in 1904, and through whom she knew the poet Rainer Maria Rilke, who acted as the sculptor's secretary for a time, and a number of whose works feature among her books. Gwen John is also documented as having met other artists including Brancusi, Matisse, Picasso and de Segonzac. Less well known are the women artists of various nationalities who she met as part of the artistic community of Montparnasse. Her letters create strong and occasionally acerbic images of some of these women. Gwen John wrote of paying social visits to the Irish sculptor Nuala O'Donel, who worked as a *practicienne* for Rodin. The Swiss painter of academic portraits and religious subjects, Ottilie Roederstein, is represented in Gwen John's correspondence as 'l'homme-femme', wearing a man's waistcoat, shirt and watch-chain. Other artists who figure in Gwen

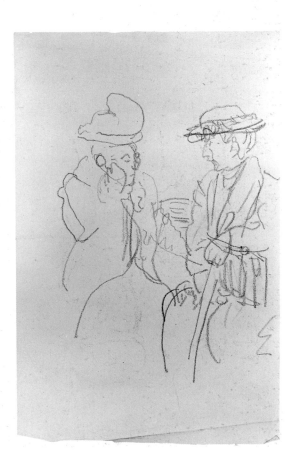

19 *Sketch of Two Women Talking*
c.1905
Pencil on paper
24.8 × 16.5 (9¾ × 6½)
National Museum of Wales

29

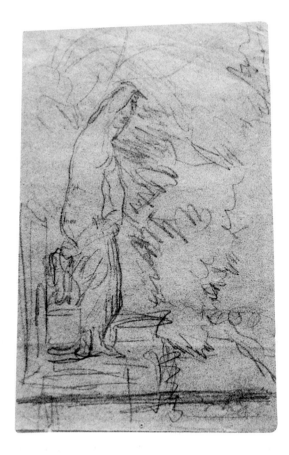

John's letters include the German painter Ida Gerhardi, who had studied at the Académie Colarossi and became known for her portraits and her paintings of scenes at the Parisian dancehall, the Bal Bullier, and Hilda Flodin, a Finnish sculptor and printmaker who exhibited at the Salons. A particularly close friend was the British painter and decorative artist Mary Constance Lloyd, who was also a friend of Duncan Grant's and who, like Gwen John, spent her career working in the French capital. Mary Constance Lloyd made her reputation at the Salon d'Automne as both a fine artist and a designer of interior decor and stage sets. Some of Gwen John's letters create a picture of herself and other women artists living and working in Montparnasse and the areas to the south-west of the city. She wrote about drawing in cafes and parks and taking boat trips on the Seine, as in an account of a visit to Suresnes, on the outskirts of Paris, with Hilda Flodin: 'we slept under the trees and drew each other and came home at night when all the river was illuminated with lanterns and windows.' Gwen John's sketches of women talking (fig.19) and of sculpture in an outdoor setting (fig.20) represent the spaces of the city as frequented and observed by women artists. Rather than Paris being the backdrop against which Gwen John made her appearance as part of the spectacle, the subject of such letters and drawings is the city through her eyes.

3

THE MODEL

From her arrival in the French capital in 1904, and for approximately a decade, Gwen John modelled in order to supplement her income. She posed for many of the artists she knew, including Mary Constance Lloyd, who painted her as a nude sitting on a bed. She also modelled for Rodin's memorial sculpture for Whistler, who had died in 1903. Although much has been made of Gwen John's sexual relationship with Rodin and of her letters to him which often create an erotic image of her work as a model, this representation of modelling is only part of the picture. The professionalisation of the modelling world in Paris and the increasingly large numbers of women artists employing life-models during this period meant that women who posed naked were not necessarily perceived as disreputable, sexually available and of lesser social standing. Modelling helped Gwen John to support herself and allowed her to remain involved in the art world while she was working. That she posed for a close woman friend, and also represented herself in letters socialising with some of the women who employed her seems to indicate that modelling and the women who did it were not so rigidly defined and demarcated.

During the period in which Gwen John was working as a model the female nude had become a significant subject for artists. Rodin's own work focused increasingly on the female nude and it has been estimated that around eighty per cent of the sculptor's surviving drawings are those which he made of female nudes late in his career. These drawings are remarkable both for their extreme economy of line and their explicit eroticism, and were exhibited for the first time *en masse* at the Bernheim-Jeune Gallery in 1907. Rodin's work was included in the exhibition *Nus*, again at Bernheim-Jeune's, in 1910, in which many of the established names in the French art world, including Bonnard, Cézanne, Denis, Degas and Vuillard showed images of the female nude. The significance of the representation of the female nude to all of these male artists is not explained by the needs of formal experimentation and development alone. The female nude had become an important sign for male professional artistic identity and creativity, and linked the role of the artist to a masculine sexuality defined around the desire for, and, by implication, possession of, women's bodies.

The particular meanings of the female nude for male artists in early twentieth-century Paris did not prevent women artists from interpreting the subject; on the contrary the cultural importance of the female nude made it a crucial subject for them. As both a woman artist and a life-model who posed for other artists it is understandable that Gwen John should

want to represent the female nude herself, and she was not alone. Suzanne Valadon, who had modelled for Toulouse-Lautrec and Renoir among others, posed naked for her own work and also employed female models. Other women artists who were not themselves models, such as Paula Modersohn-Becker (see fig.21) and Emilie Charmy were also involved in making images of female nudes and of their own bodies. Gwen John may well have met Modersohn-Becker through their mutual friend, Rilke. But this is not to argue that we can identify women artists as having a single and uniquely feminine perspective on the subject. What becomes evident looking at their work is the variety of the strategies of representation which they used, and this complexity is present in Gwen John's work.

There are extant a series of five similar drawings which Gwen John made of herself nude (fig.22). The drawings are extremely simplified. In a letter to Ursula Tyrwhitt of 1909 Gwen John wrote of experimenting with tracing and repeating her drawings in order to make them 'definite and clean', perhaps under the influence of Rodin's reductive drawing style. The female nude in all the drawings is represented standing in a bedroom holding what appears to be a sketchbook on which she is drawing. Placing the figure within a specific and everyday location, making art, implies that she is herself an artist rather than a representation of a muse, or an allegory of the art of drawing or painting (which would be signified were her environment to be excluded from the drawing). In four of the drawings the face is left completely blank, while in the fifth the features are only summarily sketched in, suggesting that although being both an artist and a model who posed for images of the female nude might have been acceptable in Parisian artistic circles by the 1900s, it was perhaps difficult for Gwen John to reconcile these identities in representation.

In addition to drawing herself, a series of nineteen life-drawings by Gwen John of different female models survive (see figs.23–4). They were probably made at the Académie Colarossi in Montparnasse which the artist attended in the mid-1900s. Because Colarossi's was inexpensive, and provided a good range of models rather than luxurious facilities, it was understood to be frequented by the more serious and hard-working artists. The brevity of Gwen John's drawings suggest that they were made during the daily *croquis* sessions when the model changed position every half an hour. The drawings represent a number of different women in a variety of standard life-room poses, sitting upright on a high stool, standing with a raised arm, or with their back to the viewer. The focus on the representation of the figure to the exclusion of

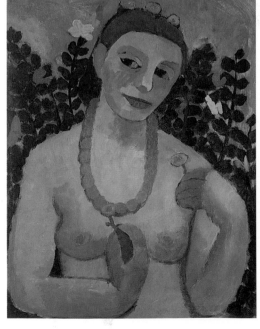

21 Paula Modersohn-Becker, *Self-Portrait with Amber Necklace* 1906
Oil on board
62.2×48.2
$(24\frac{1}{2} \times 19)$
Private Collection

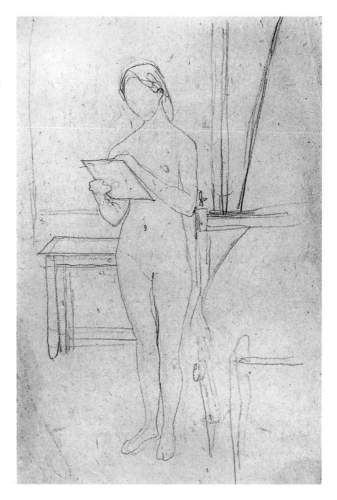

22 *Self-Portrait
Nude c.*1909
Pencil on paper
24.8 × 16.5
$(9\frac{3}{4} \times 6\frac{1}{2})$
National Museum
of Wales

the environment in which the model sits or stands was the standard format of life drawing. Gwen John also gave some attention to the representation of the facial features of the women, emphasising their individuality and their expressions, which seem to register a guarded awareness of being looked at. Our realisation that these are representations of life-models is heightened by the artist's refusal to soften the stiffness and artificiality of the poses; the women are shown obviously holding themselves in position in order to be drawn, rather than as having been caught by the artist in natural movement.

Gwen John's paintings *Girl with Bare Shoulders* and *Nude Girl* of 1909–10 explore the representation of the model further (figs.27–8). The pose of the figure is similar in both pictures, but as the viewer moves from one painting to the next the woman's hair falls onto her forehead and her clothes are pulled down to reveal her body. The relationship between the two paintings suggests the act of undressing which takes place between Goya's two famous paintings of the *Maja* clothed and naked. There was considerable interest in Goya during the 1900s. His work had been the

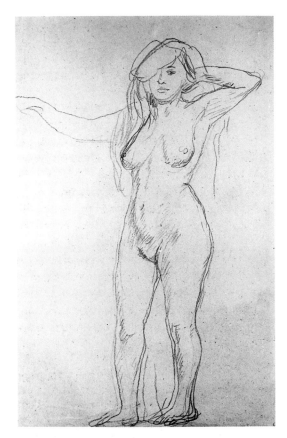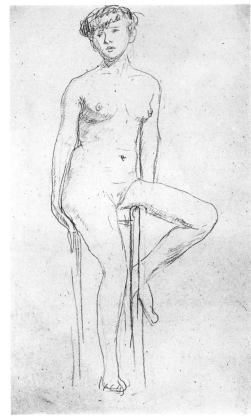

Above left
23 *Life Study,
Female Nude* c. 1905
Pencil on paper
16.5 × 24.5 (6½ × 9½)
National Museum of
Wales

Above right
24 *Life Study,
Female Nude* c. 1905
Pencil on paper
16 × 25 (6¼ × 9¾)
National Museum
of Wales

subject of a major exhibition in Madrid in 1900, and in the same year, one of the John circle in London, William Rothenstein, had published a book on the artist. However, the composition and gaze of Gwen John's model does not recreate the seductive languor of Goya's majas. Rather than reclining, she sits, somewhat stiffly, on a chair against a wall. As in Gwen John's life-drawings, we are aware immediately that the woman is modelling because of the rigidity of her pose, and her gaze represents her knowledge of the viewer's presence and recalls the look of Manet's *Olympia*, which was moved to the Louvre from its previous home in the Musée du Luxembourg in 1907.

The model for Gwen John's two paintings, Fenella Lovell, earned her living in London and in Paris posing for artists during the 1900s. Some of Gwen John's letters to Rodin represent Fenella dressed as a 'bohemienne'. This translates as female gypsy, but, of course also connoted a wild and unconventional artistic image. During the 1900s, the meanings of 'bohemian' had fused to such an extent among the circle who centred around Augustus John in Britain that their artistic image involved not only learning Romany, and dressing in approximations of gypsy costume, but even trekking around the countryside in caravans. Augustus John's painting, *Woman Smiling* (fig.25), represents Dorelia, whom Gwen John had painted as a student, wearing a scarlet dress and headscarf, and was

described by Roger Fry as a 'gypsy Giaconda'. Fenella Lovell had also posed for Augustus John, and in a photograph of herself which she sent to Rodin, inscribed in Romany, she wears an elaborate version of gypsy costume complete with beads, hoop earrings, head scarf, playing-cards and tambourine (fig.26).

Although clothes are significant in Gwen John's two paintings of Fenella, the artist did not choose to represent her model in the gypsy dress in which Fenella was photographed, and for which her brother and his paintings of women were famous. Fenella's costume in *Girl with Bare Shoulders* is notable for its stark simplicity and distinctive shape, created by the sash tied under the model's breasts. It seems to be directly influenced by the revival of the empire-line in Paris during the late 1900s in the work of the designer Paul Poiret. This modern French fashion replaced the hour-glass, heavily corseted and decorated figure with a slim and straight silhouette (fig.29). The decoration of Fenella's costume is reminiscent of a particular empire-line dress in a painting, the white dress with a large bow at the breast and wide sash worn by the duchess of Alba in one of her portraits by Goya. Referring to the duchess's costume created another interesting link to the paintings of the majas clothed and naked, as the duchess was

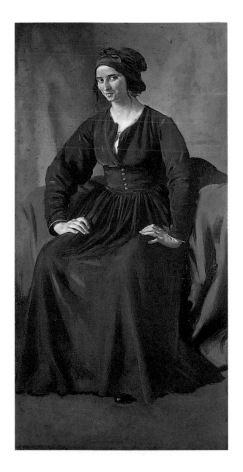

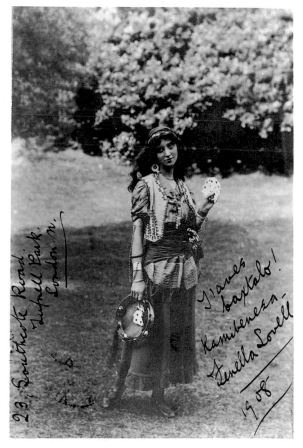

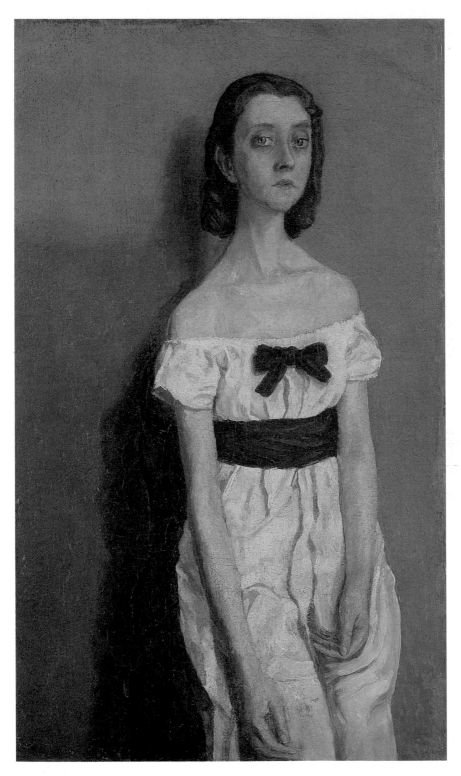

27 *Girl with Bare Shoulders* 1909–10 Oil on canvas 43.5 × 26 ($17\frac{1}{4}$ × $10\frac{1}{4}$)
Museum of Modern Art, New York, A. Conger Goodyear Fund

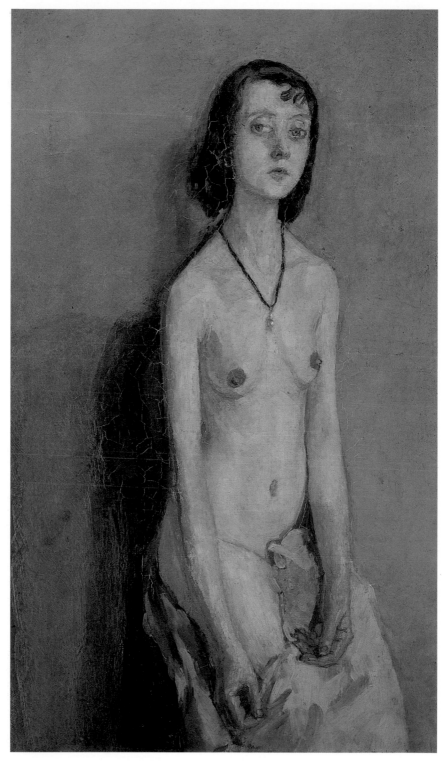

28 *Nude Girl* 1909–10 Oil on canvas 44.5 × 27.9 (17½ × 11)
Tate Gallery

described in Rothenstein's book as a scandalous figure who had modelled for the two paintings.

However the dress represented in Goya's portrait of the duchess and those designed by Poiret one hundred years later were luxurious and beautifully crafted. By contrast Fenella's costume in *Girl with Bare Shoulders* appears rather tawdry. Its rumpled sleeves, the fabric which has been unevenly pulled in by the sash and the gathered neck which has been pulled down over the shoulders indicate that rather than being a dress it is actually a form of undress, a chemise decorated and worn in a cheap imitation of Parisian *haute couture*. Neither is Gwen John's *Nude Girl* completely naked but rather *déshabillé*, her chemise is

around her thighs and she is wearing a pendant on a neck-ribbon. Gwen John probably saw paintings from different periods which showed women in their underwear, signifying distinctly unrespectable identities. Manet's interpretation of Zola's Parisian courtesan, *Nana*, was exhibited at the Musée du Luxembourg in 1904 and at Bernheim-Jeune's in 1910, and represents Nana standing in her frilled petticoats and with the corseted voluptuous figure which was fashionable during the 1870s (fig. 30). The Slade tutor Steer, himself an admirer of Manet, painted *The Chemise* in

29 Georges Lepape, illustration from *Les Robes de Paul Poiret*, published in Paris in 1911.

32 'Chemises du Jour' from a Bon Marché catalogue, 1911.

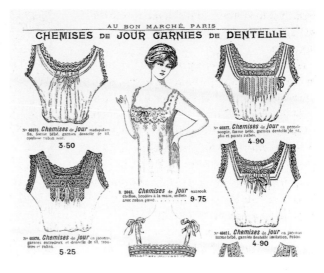

around 1896, in which a woman with a curvy figure and choker, in vogue during the late-nineteenth century, sits in a dingy attic room, her chemise slipped off her shoulder to reveal her breast (fig. 31). *Girl with Bare Shoulders* and *Nude Girl* can be interpreted as drawing on such images and reworking them with the feminine body shape which was fashionable in the early twentieth century. By the 1910s Bon Marché advertisements showed slim figures in empire-line chemises, often decorated with a bow at the breast, replacing the matronly figures in voluminous underwear of a few years earlier (fig. 32).

The two paintings of Fenella bring together codes of representation: a woman both dressed and undressed, the inclusion of a chemise in both paintings (which has its own resonance), and the specific modernity and Frenchness of the slender empire-line figure. It seems that *Girl with Bare Shoulders* was shown at the NEAC in 1910, and *Nude Girl* was bought by a member of the NEAC and presented to the Contemporary Art Society. Given the interest of the NEAC in French art and the precedent of paintings such as *A Lady Undressing* and *The Chemise* made by members and Slade tutors Tonks and Steer, Gwen John's play upon the viewer's expectations of images of the female nude and of the Parisian artist's model in her paintings of Fenella are likely to have been recognised.

Gwen John's representation of the model was not confined to her work as an artist. During the mid-1900s she wrote a series of letters in French which she sent to Rodin; however, the letters were addressed to a fictional sister called 'Julie', signed 'Marie', and refer to Rodin throughout as 'Mon Maître'. In this correspondence, Marie's statements that she is a model, not an artist, are combined with a structure and content which creates a particular image of the Parisian artist's model. The first of the letters is accompanied by a note which reads: 'My dear master, I found a fragment of a novel in the forest. It interested me and I copied a little of it for you. Please tell me what you think of it.' Enclosed, written on a larger piece of paper,

Far left
30 Edouard Manet,
Nana 1877
Oil on canvas
154 × 115
(60¾ × 45¼)
Hamburger
Kunsthalle

31 Philip Wilson
Steer, *The Chemise*
c.1896
Oil on canvas
76.2 × 61 (30 × 24)
Destroyed by fire

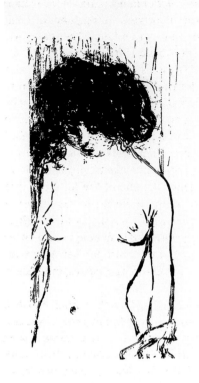
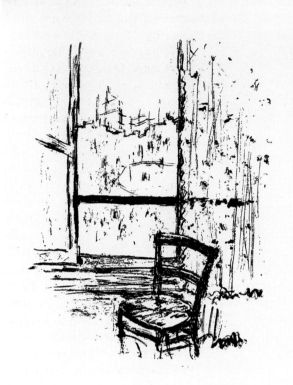

and beginning mid-sentence as if it were torn out of a larger work, is the 'excerpt' from the 'novel', in which Marie tells Julie of her rendezvous with her 'Maître' in his atelier. The names Gwen John used in this correspondence have some significance. Marie is of course the French version of the artist's middle name, Mary, but it was also redolent of Parisian left-bank artistic life. Writing of 'Student Life in the Quartier Latin, Paris' in the *Studio* in 1902, Clive Holland enthused about 'the charming if errant Mimi Pinsons, Marcelles, Suzannes, Yvettes and Maries' who inhabited the area.

The choice of the names 'Marie' and 'Julie', and Gwen John's representation of the correspondence as an excerpt from a novel suggest that she had in mind the vogue for epistolary novels in France during the late nineteenth and early twentieth centuries. Rodin himself was an admirer of such writing. He was described as having a particular love of the works of Jean Jacques Rousseau, and owned the complete writings of the author of *Julie, ou la Nouvelle Heloise*, a novel in which the heroine's letters chart her love for her tutor. Gwen John wrote to Rodin of reading Samuel Richardson's *Pamela*, and about borrowing a copy of *Clarissa* from her local library after he had spoken of it. The popularity of these novels was partly due to a particular interpretation given to them at the turn of the century. The eighteenth century was perceived as a time of sexual

33 and 34
Pierre Bonnard,
two illustrations
from Peter Nansen's
Marie, published in
Paris in 1898
Private Collection

licence, and Rousseau's and Richardson's fictional accounts of love affairs and seductions recounted in the form of private correspondence and writings, often between women, were read in this light. The genre was revived as a type of erotic literature by authors during the late nineteenth and early twentieth centuries. Peter Nansen's novel *Julie's Diary*, first published in 1893, was written as a journal in which a young woman recorded her seduction by an older man of the world. It was followed by his novel *Marie*, in which an upper-class man told of his affair with a midinette. The French translation of *Marie*, which was published in Paris in 1898, was illustrated by Bonnard with drawings of his mistress and model as Marie, in which she is represented undressing and naked (fig. 33). Eroticism runs through Gwen John's correspondence. In one of the letters 'Marie' writes to 'Julie' that she feels she can be more daring in her letters to her sister than would be the case if she were writing to her 'Maître'. Accounts of undressing for her modelling work and in her own room, of her body and appearance, and of her sexuality and desire for her *Maître* are represented as the sharing of intimate secrets in the correspondence of two women.

Marie's letters to Julie create a vision of the French capital which is very different to the the city of professional work which appears in the correspondence of Gwen John the artist. Marie's Paris is represented as an eroticised terrain in which her *raison d'être* lies in soliciting favourable looks and comments on her appearance from her *Maître*, from men in the street and from some of the artists for whom she models. The letters contain numerous accounts of Marie being followed and approached by *rodeurs*, or prowlers, and of sexual advances made to her by men, on the omnibus and even at the Louvre. Marie also wrote of a visit she made to the Gaîté Montparnasse, a *café-concert*, with Ida Gerhardi and three other women. She described her enjoyment of the bawdy acts, the actresses with their bare arms and shoulders, and her wish that her lover were with her watching the performance. Marie's room is contrasted with Parisian public space in these letters, and described almost as a part of herself. In one of her letters to Julie, Marie writes of both her body and her room being 'clean and pretty' in anticipation of a visit from her *Maître*. The association between the interior and the female body was also made in Bonnard's illustrations. His drawings represent Nansen's Marie naked in a room, often a bedroom, and one work shows only the interior, a chair, window and lace curtain (fig. 34). The room in Bonnard's illustrations can be interpreted as a sign for the interior life of women, supposedly revealed in Nansen's fictional writing of 'private' diaries and letters. Similarly, in Marie's 'private' letters to Julie the room is a part of the model's identity, and is the setting for her explorations of her inner life, and of her body, in her correspondence with her 'sister'.

4

INTERIORS

A critic writing about the NEAC exhibition in the spring of 1902 remarked on the large number of paintings of interiors. His review took the form of a conversation between the exhibits, in which each one argued for its own approach to the subject. Gwen John's painting, which is now lost, was imagined in debate with a work exhibited by Philip Wilson Steer, among that of other artists. The critic characterised Gwen John's approach to the subject as drawn from the work of the 'primitives' and their use of precise contours and modelling in order to create representational equivalents of objects. He contrasted this with Steer's impressionistic concern with the effects of light. This review indicates how important the interior had become as a subject for painters during the early twentieth century; it also suggests the possibility of an interpretation of Gwen John's interior paintings which breaks out of the reading of them as the sign for her individual life, and places them in relation to, or in conversation with, the work of her contemporaries.

If Gwen John's paintings are understood as images of interiors rather than straightforward descriptions of the rooms in which she lived, her depiction of specific furniture, decor and spaces become significant. A wicker chair furnishes the rooms in many of Gwen John's interiors, appearing in the paintings known as *A Corner of the Artist's Room in Paris* (fig. 35) and *A Corner of the Artist's Room in Paris (with Open Window)* (fig. 36), and that titled by the artist *La Chambre sur la Cour* (fig. 37), among others. Because it was relatively inexpensive, light and easily portable the wicker chair had become a standard feature of artist's rooms, and consequently almost a symbol of artistic identity. Clive Holland's article on Parisian art students of 1902 was illustrated with a photograph captioned 'A Typical Studio', in which a wicker chair sits in the foreground (fig. 38). William Rothenstein's painting, *The Browning Readers*, which was exhibited at the NEAC in 1900, represented his wife and her sister in an interior decorated in an artistic 'oriental' style with sculpture, china, pictures, and a wicker chair in which the artist's wife is sitting. However, Gwen John's interiors are never decorated with tasteful and valuable *objets d'art*. In addition to the wicker chair, a small pine table sometimes appears, a type of furniture which was cheap during this period and which furnished many artists' Parisian rooms. Paula Modersohn-Becker described her studio in Montparnasse in the 1900s as 'wholesome and bright, with a few pieces of pine furniture'. The deep-set windows and slanting ceilings of several of Gwen John's interior paintings identify the rooms as attics. A studio under the eaves was almost a cliché of artistic

35 *A Corner of the
Artist's Room in
Paris c.*1907–9
Oil on canvas
31.7 × 26.7
($12\frac{1}{2}$ × $10\frac{1}{2}$)
Sheffield City Art
Galleries

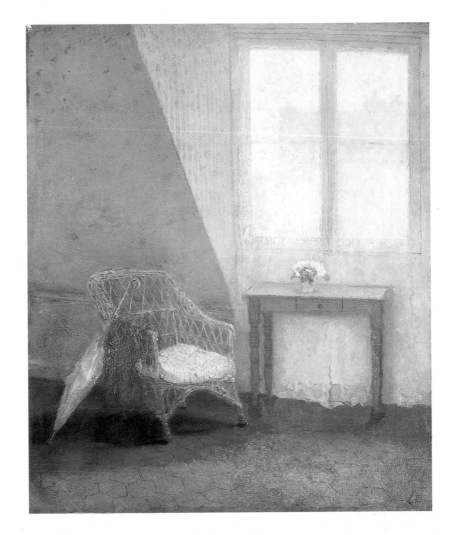

living. As early as the mid-nineteenth century a painter toiling in his
garret had appeared in a humourous drawing of a cross-section of a typical
Parisian mansion block showing the types of people inhabiting its different
floors. Matisse had painted his *L'Atelier sous les toits* in 1901–2, and in
1906 Mary Constance Lloyd exhibited a painting titled *La Mansarde* at
the Salon d'Automne. Gwen John's knowledge of contemporary interior
decor would have been enhanced by her friendship with Mary Constance
Lloyd whose reputation as a designer led to her eventual nomination as a
sociétaire in decorative art at the Salon d'Automne. The significance of
the simple furnishings and spaces which appear in Gwen John's interior
paintings, and her awareness that they created a type of artistic image, is
evident in her critical account of the luxury in which Nuala O'Donel lived.
She wrote of O'Donel's 'Persian' interior decor as having transformed what
had been a studio into a room which looked like a drawing-room, and as
contrasting unfavourably with the simplicity that denoted an artistic
lifestyle.

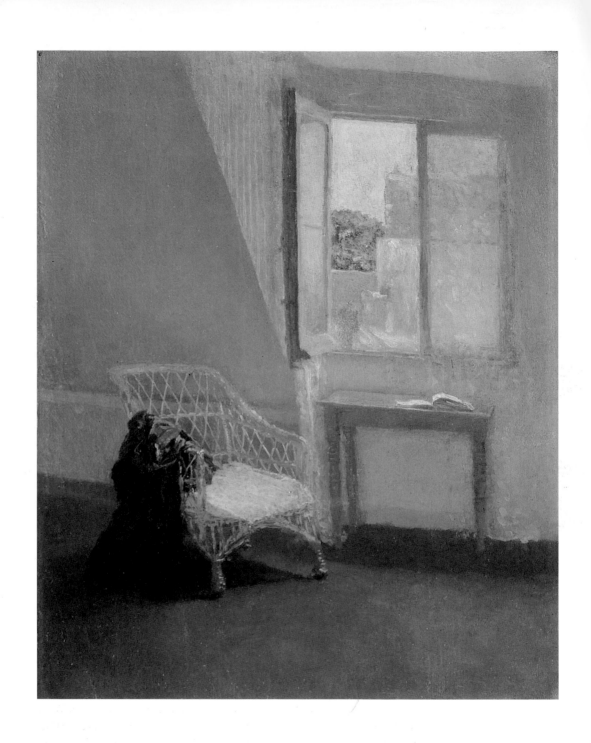

36 *A Corner of the Artist's Room in Paris (with Open Window)* c.1907–9
Oil on canvas mounted on board 31.7 × 25.4 (12½ × 10)
Private Collection

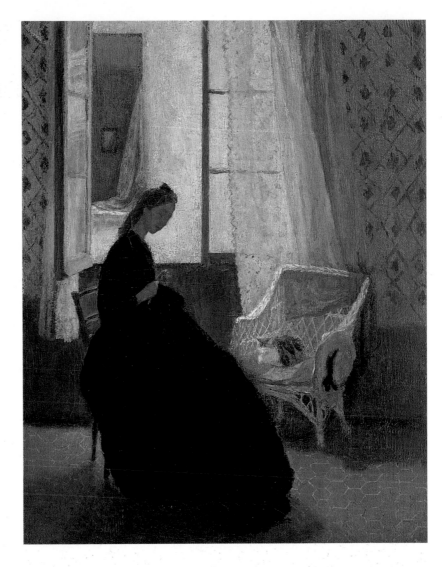

37 *La Chambre sur
la Cour c.*1907
Oil on canvas
31.8 × 21.6
($12\frac{1}{2} \times 8\frac{1}{2}$)
Collection of Mr and
Mrs Paul Mellon,
Upperville, Virginia

In her concern with painting rooms which were not richly or
elaborately decorated, Gwen John had little in common with her teachers
Tonks and Steer. Their paintings of interiors often represent women
wearing pretty dresses in rooms filled with fine polished furniture, plants
and china. Among the artists working in London, Gwen John's interiors are
in greater sympathy with the painters who were to form the Camden Town
group in 1911, such as Walter Sickert and Spencer Gore. For these artists,
simple, often drab, domestic interiors were a significant subject. In a state-
ment made in 1910 before the formation of the group, Sickert elucidated
his belief that 'serious' art avoided the drawing-room, and flourished in the
scullery or kitchen. The division Sickert made between the different rooms
signified the divide between classes. In dismissing the drawing-room as a
subject for art, Sickert was rejecting the wealthy and tasteful surroundings

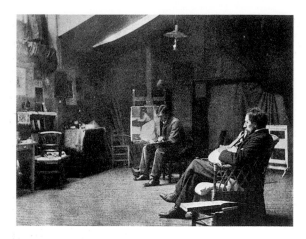

38 'A Typical Studio' from Clive Holland's article 'Student life in the Quartier Latin', *Studio*, vol. 27, 1902.

of the upper classes in favour of lower-class scenes and subjects. There are obvious similarities between the work of artists associated with the Camden Town Group, such as Gore's *Interior: Fireside Scene* (fig.39) and interiors by Gwen John, including the painting now known as *The Teapot* (fig.40). As in Gwen John's interiors, Gore's painting represents a room which could be described as ordinary, not expensively or fashionably decorated, and which is furnished with a wicker chair. The low brown tones of *The Teapot* are similar to those used by Camden Town painters, particularly Sickert, who exhibited his work in Paris during the 1900s, and was described as painting in 'dirty mud' colours. However, there are important differences between Gwen John's paintings and the work of the Camden Town painters. At the foundation of the Camden Town group it was decided to exclude women artists from the organisation. For Sickert and his fellow members, 'serious' art was men's business. Painting a female nude in a gloomy bedroom, a maid working in a kitchen, or a woman reading among a clutter of ornaments and pictures claimed feminine domesticity, albeit a shabby and tattered version, as a subject for the male painter's art. By contrast, in Gwen John's painting *The Teapot*, the bric-à-brac which crowds Gore's mantelpiece is swept away and replaced with a single pot of paintbrushes. The austerity of Gwen John's interior with its plain furniture, the presence of the teapot and cup, what appears to be a milk jug, and the newspaper and book, suggest an artist's studio during a break from work. Although Gwen John's paintings of rooms do represent the type of interior which Sickert encouraged his colleagues to paint, her paintings of domestic spaces represent the 'simple' room as a site for and subject of a woman artist's work.

The significance of the mundane and everyday was also part of the Symbolist

39 Spencer Gore, *Interior: Fireside Scene* c.1910 Oil on canvas 50.8 × 60.9 (20 × 24) Leeds City Art Gallery

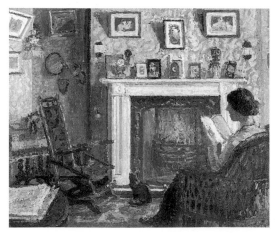

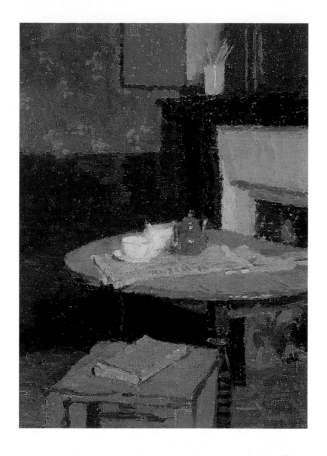

40 *The Teapot
(Interior: Second
Version) c.*1915–16
Oil on canvas
33.3 × 24.1
(13¼ × 9½)
Yale University Art
Gallery, Collection
of Mary C. and
James W. Fosburgh

aesthetic of the late nineteenth century. Domestic events, surroundings and objects were represented as sources of poetry and mystery in Symbolist art and literature, as in Mallarmé's sonnet of 1867 in which lace hanging against a window, which appears to float and vanish against the glass, becomes the evocative starting-point and link for an intricate web of images. In several of Gwen John's paintings a lace curtain, whose fragile presence is suggested in white and grey tones, is a vehicle for indicating the light filtering in from the window, a light which picks out each object in the room distinctly but also joins them in one atmosphere. The lace curtain appears in *La Chambre sur la Cour*, in which the open window, against which the female figure is silhouetted, is echoed by a parallel window across the courtyard through which we glimpse a shadowy interior. In Symbolist thought, the interior was also resonant of inner life, of subjectivity. As Belinda Thomson has discussed, the interior became an important subject in the Symbolist theatre which was performed in Paris in the 1890s. In the work of the Belgian poet and playwright Maurice Maeterlinck, an interior was both the setting for the unfolding drama and symbolic of the interior lives of the characters. Gwen John knew of Maeterlinck's work, her book collection includes one of his late essays, and the title of a painting by the artist exhibited in 1903, *Alladine and Ardiane*, could have been influenced by his play *Alladine et Palomides*, which

was published in 1894 with another drama titled *Intérieur*. Stage sets representing interiors contributed to the ambience created in Symbolist theatre, and artists, including Vuillard, were employed as designers. Gwen John's understanding of the painting of interiors as akin to the design of stage sets, arranged and coloured in order to suggest a certain meaning and create atmosphere, would have been heightened by her friend Mary Constance Lloyd's work as a theatre designer.

Gwen John's interior paintings have affiliations with the early twentieth-century representation of the Symbolist interior both in Scandinavian art and in the work of French interior painters. She is likely to have known of the Danish painter Vilhelm Hammershøi, as Rilke was a great admirer of his work and planned to write a monograph on the artist after seeing his paintings in 1904. Hammershøi later became a friend of Ida Nettleship's family in London and had a private exhibition at Ada Nettleship's home. The interiors in Hammershøi's paintings are either bare or austerely furnished; they are sometimes unoccupied, and when inhabited they house a solitary woman wearing a plain black dress and with smooth hair, similar to the female figure in Gwen John's *La Chambre sur la Cour*. Like Gwen John's interiors, Hammershøi's rooms are not settings for the busy group scenes of domestic life represented by some of the French interior painters. They evoke stillness. This is nowhere more evident than in his paintings of empty rooms such as *Study of a Sunlit Interior* (fig.41). The sense of a moment frozen in time is also created by Gwen John in her paintings *A Corner of the Artist's Room in Paris (with Open Window)* and *A Corner of the Artist's Room in Paris*. In both paintings, objects have been arranged in order to suggest that time has been interrupted and suspended,

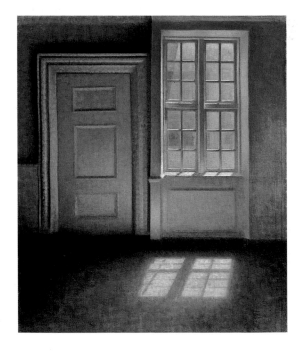

41 Vilhelm
Hammershøi, *Study
of a Sunlit Interior*
1906
Oil on canvas
55×47 ($21\frac{3}{4} \times 18\frac{1}{2}$)
C.L. Davids Fond and
Collection, Copenhagen

the book left open by the window, the parasol leaning against the wicker chair, and the coat or shawl casually thrown over it. These are signs of an absent occupant, identified by the parasol as a woman. The empty chair, which also featured in Hammershøi's work, was a device which had been used by Vermeer. Gwen John is known to have admired Dutch interior painting, a taste which she shared with many of her contemporaries, so much so that to be compared with the Dutch masters was an accolade in art criticism of the time.

A term used by French critics in the 1900s to praise modern interior painters who, it was felt, had successfully emulated the Dutch masters was *recueilli*, which translates as 'contemplative' or 'meditative', from the verb which means to collect or gather in. Gwen John used the word to describe both her own disposition and the value of her artistic vision in a letter to Ursula Tyrwhitt of 1910, and it appears in other writings of hers. Far from indicating Gwen John's seclusion, in using this term she was appropriating, as a personal characteristic, a quality which was seen as valuable within contemporary art and art criticism. Gwen John's paintings of interiors themselves contain signs of life beyond the walls of the rooms. The window is open onto the outside world in one of the paintings of the corner of the artist's room; in the similar picture in which the window is closed, the parasol propped against the chair and the bunch of flowers suggest that the occupant has come in from outside. The figure by the open window in *La Chambre sur la Cour* has placed her hat on the chair opposite, and *The Teapot* is resting on a newspaper. A predilection for contemplative solitude also had a wider cultural resonance as an artistic trait during this period, and not only in writing on Cézanne. At the time of his discovery of Hammershøi's work, Rilke was planning to write on the Danish author Jens Peter Jacobsen. Jacobsen's writing was melancholy and introspective in mood, characteristics epitomised in the decadent hero of his novel of 1880, *Niels Lyhne*, which is represented in Gwen John's book collection by a 1928 edition. Rilke's attraction to Hammershøi's work seems to have been due to the withdrawn, quiet and austere quality of his interiors, in which Rilke could have identified some similarity with his own ideas on the way of life necessary for thought and creativity, given voice in his poetic statement that 'only solitaries shall behold the mysteries'. A belief in an artist's need for a simple lifestyle and time alone devoted to work was shared by Gwen John, Hammershøi and Rilke, but the type of room which signified this way of life is not the same in the work of the two painters. As Poul Vad has remarked, Hammershøi's interiors are unostentatious and daringly spartan when compared with the decorative excesses of most rooms of the period. Nevertheless they are well-appointed and often contain dark, elegant, empire-style furniture, very different from the Parisian artistic simplicity of Gwen John's interiors.

In France during the 1900s some of the painters who had been associated with Symbolism were developing their interpretation of the interior. The first group exhibition of *Peintres d'intérieurs* took place in Paris in 1905, and included the work of Bonnard and Vuillard; both these artists

exhibited regularly in the French capital at the Salon d'Automne and at Bernheim-Jeune's, where Gwen John is likely to have seen their art. In its subject matter and composition, Vuillard's *Madame Vuillard Sewing, rue Truffaut* (fig.42) shares obvious characteristics with Gwen John's *La Chambre sur la Cour*. Both paintings represent a woman sewing in a room, a domestic subject which had associations with Dutch interior painting. Critics noted Vuillard's ability to transform 'the most common sights', such as the furnishings and decoration of the modern Parisian apartment in which the woman is sitting, into art. This seems to echo the praise which Gwen John's work received for looking to 'the colour which ordinary life wears' at the Spring 1908 NEAC exhibition, where *La Chambre sur la Cour* was shown with the portrait of Chloë Boughton-Leigh. But the techniques used by Vuillard and Gwen John during the 1900s are dissimilar. In Gwen John's painting the figure, and each object and surface in the room, are concisely delineated and described with a smooth, unbroken paint surface. The difference between things, such as the dress, the chairs and the tiled floor, is distinct, and everything has its own subtle but individual colour and identity. However, Vuillard increasingly played down colour contrasts and focused instead on the tonal similarities of different objects; his painting technique unites the variety of surfaces in his interiors, such as the lace curtain and Mme Vuillard's blouse. As Andrew Ritchie noted in his work on Vuillard, this emphasis on tone suggests an affiliation with Verlaine's poetry (a 1928 edition of which is among Gwen John's books), particularly the poem in which Verlaine dismissed colour along with the rest of literature, distinguishing poetic expression as concerned above all with 'nuance'.

In Vuillard's paintings the identity of individual things is evoked, but is secondary to the decorative plan of the whole. His weaving together of a variety of spaces and surfaces into a unified tonal pattern was likened to a 'rich oriental carpet' in a 1905 review of the Salon d'Automne.

At the 1924 Salon des Tuileries Gwen John exhibited a painting now known as *Interior (Rue Terre Neuve)* (fig.43) in which the artist's handling of paint and use of tone are evidence of a technical approach to the interior more like Vuillard's. It is one of five surviving paintings by Gwen John of an empty room, but with human presence suggested by an arrangement of objects on a tabletop. There is a second painting of this composition, two paintings in which a Japanese doll sits on the table, and another with a straw hat, cotton-reel and fabric. In each of these paintings spaces and objects are suggested rather than

42 Edouard Vuillard, *Madame Vuillard Sewing, rue Truffaut c.*1900 Oil on cardboard 50 × 37 (19¾ × 14½) Musée des Beaux Arts, Lausanne

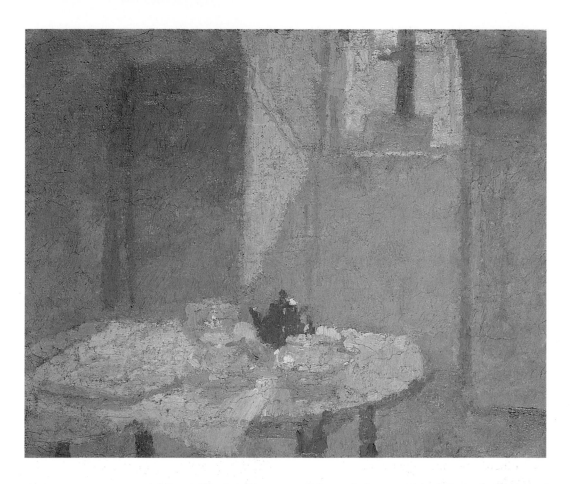

43 *Interior*
(Rue Terre Neuve)
c.1920–4
Oil on canvas
22.2 × 27 (8¾ × 10¾)
Manchester City
Art Galleries

rigidly outlined, with an exquisite and clever manipulation of colour and tone and the texture of the brush strokes clearly visible. The teapot appears in *Interior (Rue Terre Neuve)* as the one distinct object, defined as an area of colour at the centre of a room in which everything else, the walls, window and the other things on the table-top, are conceived as part of a grey/white tonal arrangement. In the two paintings of the interior with a Japanese doll, the dark, bobbed hair of the doll and the blue and scarlet of her clothes are the coloured focal point in surroundings evoked by subtle shifts in a rich ochre/gold scheme. The plain room represented in all five paintings is unlike many of Vuillard's highly decorative interiors with their profusion of patterned wallpaper and fabrics and heavy furniture. The arrangement of the window, walls and sloping roof in these late interiors indicates that the room is an attic, suggesting that it was drawn from the artist's top-floor apartment in Meudon. But these paintings should not be interpreted as straightforward records of one of Gwen John's rooms at rue Terre Neuve. The artist's use of a similar spatial structure to explore different and complex gradations of tone and colour emphasises that these interiors were creations of paint on canvas.

51

RELIGION

The contemporary interior had a further significance in the visual arts in France and in Gwen John's paintings; it had become one of the settings for the depiction of sacred figures and events in the work of Catholic artists. Gwen John's interest in religion has been traced by Ceridwen Lloyd-Morgan in her study of the artist's papers. From 1910 onwards her writings include religious extracts and meditations, by 1912 the artist was receiving instruction in the Catholic faith, and was finally received into the church in about 1913. Gwen John is recorded as having been a part of the Catholic community in Meudon; she attended church there and formed a strong association with a local chapter of Dominican nuns. Her spiritual involvement in Catholicism had its parallel in her work, a connection made in her description of herself as 'God's little artist', and from the 1910s onwards some of her work can be seen to develop religious themes, inflected by the modern religious revival in French art.

Between c.1910 and 1911 Gwen John made two paintings which are the first among her works to suggest a religious influence: *A Lady Reading* (fig.44) and *Girl Reading at the Window* (fig.45). The artist wrote to Ursula Tyrwhitt that she had tried to make the head of *A Lady Reading* look like 'a vierge of Durer'. The Dürer painting Gwen John seems to have used is his *Virgin with Child (Virgin with the Pear)* (fig.46), which was in the collection of the Uffizi, but reproduced in art-historical literature in the 1900s. Giving the figure a face which was intended to be recognised as Mary obviously evokes a religious meaning, and this is enhanced by the lady's pose and surroundings. A female figure with long, loose hair, shown full length and reading by a window in a domestic interior was the standard iconography of images of the Annunciation made by northern-European artists from the medieval period onwards, such as in Rogier van der Weyden's painting, housed in the Louvre (fig.47). In the work of van der Weyden and his contemporaries, the room is often tilted up behind the figure in order to frame it, and the furniture and decoration of the interior is depicted in great detail. Gwen John adopted a similar arrangement of space, and represented an early twentieth-century room with wicker chair, light wood furniture and wallpaper. The modernity and Frenchness of the interior is also indicated by the curtain in *A Lady Reading*. Red-and-white checked material appeared as a furnishing fabric in domestic scenes painted by Bonnard, and at the Salon d'Automne of 1908 Mary Constance Lloyd exhibited a design for a fan whose title was *La Nappe aux carrés rouge*. In the second of Gwen John's paintings the checked fabric is replaced by a lace curtain, which, as we have seen, had its own significance in interior painting. As

44 *A Lady Reading*
c.1910–11
Oil on canvas
40.3 × 25.4
(16 × 10)
Tate Gallery

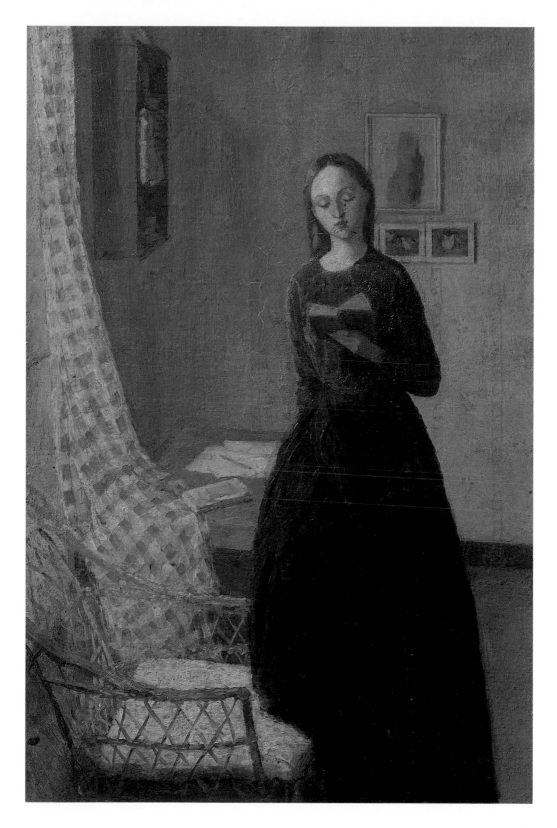

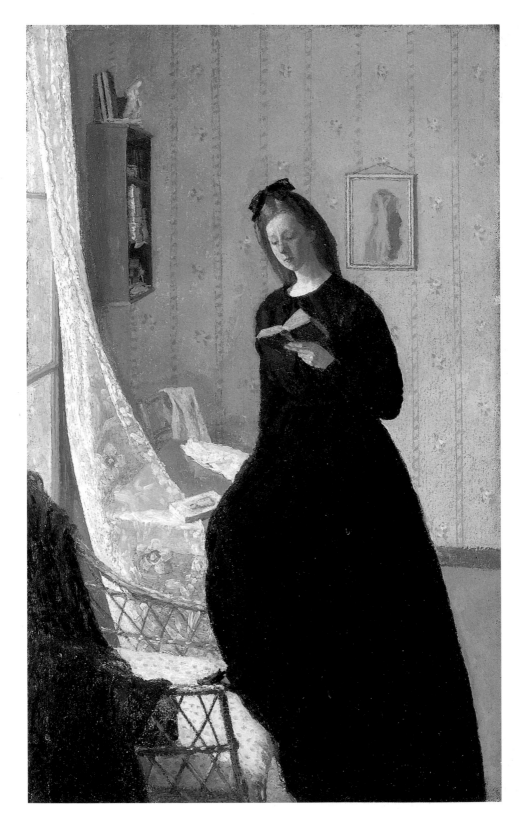

was common in paintings of the Annunciation, van der Weyden paid great attention to Mary's gown with its expansive folds of fabric. The fifteenth-century robe falling from gathers at the neck is replaced in Gwen John's paintings first by a blouse and skirt, and then by a waisted dress. Nevertheless, the dark muted colour and the spreading skirt of the plain costume in both paintings, and the long sleeves and simply cut neck, are reminiscent of paintings of the Virgin. As in Gwen John's paintings, many depictions of the Annunciation from van der Weyden's period show Mary holding or reading a book. The Virgin's book had various interpretations, as a sign of Mary's wisdom, or of her faith, because a small, thick, hardback book held by a lady usually represented a Book of Hours, a prayer book used by medieval Christians. Although the figure reading in Gwen John's paintings is solitary, a poem by a literary contemporary known to the artist shows that she was not alone in representing an Annunciation scene without a visible angel. In Rilke's *Annunciation* (*Words of the Angel*) which was published as part of his *Book of Images* in the 1900s, the angel's speech indicates that his presence is felt, rather than seen:

But still you keep your solitude
and hardly notice me:
I'm but a breeze within the wood,
you, Lady, are the Tree.

Gwen John replaced the head of the Virgin with a representation of her own face in *Girl Reading at the Window*, but there are none of the compositional signs which indicate to the viewer that the painting should be interpreted as a self-portrait. Rather, the artist painted an image which can be interpreted as an Annunciation, using her own face as a model for the young Mary.

Gwen John's *A Lady Reading* and *Girl Reading at the Window* are placed in context when we look at the work of Maurice Denis, an artist and art theorist who had a powerful influence on the revival of religious art in France. Denis had been associated with Bonnard and Vuillard during the 1890s. They had worked together on developing an art which was not tied to realistic description; rather, the artist's manipulation of the formal arrangement of the work was to be responsible for its emotive power. But Denis's devout Catholicism, expressed in his preoccupation with the role of art in religion, increasingly distanced him from Bonnard and Vuillard. Gwen John chose one of Denis's statements on art as the foreword to her one-woman exhibition at the New Chenil Galleries in London in 1926. She had it printed untranslated, thus identifying herself fully with the type of modern French art he advocated. Gwen John's inclusion of Denis's *pensée* in her own catalogue, surely an acknowledgement of the importance of his influence and the fact that his art and writings were highly visible in the French capital during the early twentieth century, suggests that she knew of his work from an earlier date. Denis showed his work at various Parisian galleries during the 1900s and 1910s, including the Salon d'Automne, Bernheim-Jeune's and the Salon de la Société des Artistes Decorateurs. In 1912 he published a collection of his writings on art, which had previously been featured in French art magazines, as *Théories 1890–1910: Du Symbolisme et de Gauguin vers un nouvel ordre classique*, and this was followed in 1922 by a series of articles in which he outlined his ideas of what modern religious art should be, *Nouvelles théories sur l'art moderne sur l'art sacré 1914–1921*. Denis's work also took him close to Gwen John's home. During the late 1900s he had been commissioned to design a decoration for the house of a patron at Meudon, and in 1916 he designed a stained-glass window depicting Joan of Arc for the entrance door there.

In Denis's art biblical scenes take place in everyday surroundings, peopled by figures in modern dress, an approach typified in his painting *The Visitation* (fig.48). Denis's painting of Mary's visit, while pregnant, to her cousin Elizabeth was made in 1894 when his own wife was expecting their first child, and as critics have noted she was usually the model for Mary. The two women wear clothes of the 1890s, and the location of the visit was the Denis family home. According to Denis it was not only contemporary settings and costumes which were to rejuvenate religious art. Modern representational techniques were also essential. In his *Notes sur la peinture religieuse*, first published in 1896 but reprinted as part of his *Théories* in 1912, he argued against the *retardaire* nature of much contemporary religious art, exemplified in paintings such as *Le Mois de Marie* by Gwen John's acquaintance Ottilie Roederstein (fig.49). For Denis, religious emotion was to be created through the beauty of the painter's technique, not through hackneyed images of piety or religious ecstasy. But Denis's conception of modern religious art did not go as far as a move towards abstraction. He argued that expressing our collective human *vie intérieure* meant using an artistic language which could be understood by

48 Maurice Denis,
The Visitation 1894
Oil on canvas
103 × 93 (40 × 36½)
Hermitage,
St Petersburg

49 Ottilie
Roederstein, *Le Mois
de Marie*
Date, dimensions
and whereabouts
unknown

the majority of people. Denis revered Cézanne and saw his own work as a development from Cézanne's art, figurative yet not academic, and Gwen John seems to have shared this admiration and approach. The Denis *pensée* which Gwen John used for her Chenil exhibition was an expression of the artist's desire to organise work, thought and life, and 'comme disait Cézanne, ma sensation', and she could have seen important exhibitions of Cézanne's art at the Salons d'Automne of 1904 and 1907. Gwen John's interest in Cézanne's work can be specifically linked to Denis and the revival of Catholic art not only because of the quotation she used in her Chenil catalogue, but also because a technical development which suggests the influence of Cézanne's paintings took place with the onset of her work on religious themes. There is evidence of a change in the artist's style in the lightening of tone between *A Lady Reading* and *Girl Reading at the Window*. With the commencement in about 1913 of the six surviving paintings of Mère Poussepin (fig.50), which the artist developed from a prayer-card portrait of the foundress of the order to which the Meudon nuns belonged, appears a paint surface made up of rhythmic touches of paint, which Gwen John was to adopt throughout her later work in oils. In his *Old Woman with a Rosary* of 1895–6, which was shown at the 1907 Salon d'Automne, Cézanne had united his advancing technique with a religious subject. Cézanne's influence can also be traced in Gwen John's art to the advent of a new structure to her working process. In addition to the six paintings of Mère Poussepin, there are eight extant portraits of a nun in a pose and costume which recall Gwen John's portraits of the foundress of the order, and two other paintings of a younger nun. Gwen John was working in series, as Cézanne did, notably in his Mont Sainte-Victoire paintings.

She wrote of her change in technique to Ursula Tyrwhitt in 1916: 'I think a picture ought to be done in 1 sitting or at most 2. For that one must paint a lot of canvases probably & waste them.'

Catholicism also influenced the perception of artists and their role as creators. Cézanne was represented as a holy figure by several critics. In 1907 Maurice Denis wrote of Cézanne's struggle on canvas as being similar to that of a saint between spirit and flesh. The comparison was also made by Cézanne himself. In a letter to his dealer, Ambroise Vollard, which Vollard included in his book on the artist, published in Paris in 1914, Cézanne likened his own artistic quest to the search of Moses for the promised land, and asked the question, 'Is Art, then, a priesthood demanding pure beings who belong to it completely?' Gwen John's self-identification with religious figures is evident in both her art and writing. In her *Girl Reading at the Window*, the artist replaced the Dürer portrait of the Virgin which she had used in *A Lady Reading* with her own face, and in a note dated 1914 wrote 'Last night the thought came to me to take courage and decide to acquire these virtues – to become a saint'. It was not only those artists living and working in France for whom the Catholic faith was significant. Converts among those involved in artistic circles in Britain included Eric Gill, and Gwen John's friend and sitter Chloë Boughton-Leigh.

For Gwen John, her religion and her work as an artist were perhaps most obviously intertwined when she began to draw while she was at church. Images of church scenes were also made by the artist's contemporaries. Denis's painting of *c.*1890, *Audi Filia* is an extremely stylised composition of women in church, and Vuillard's *The Chapel in the Palace of Versailles* of 1918 shows a back view of women in smart hats sitting in the ornate chapel. Gwen John made drawings of people in church from the 1910s onwards. Denis had stressed the importance of drawing in an article first published in 1917 and included in his 1922 book on new religious art. Gwen John's church drawings are usually back or side views of members of the congregation, and there was a development in her style and the media she employed. There are extant naturalistic sketches of a church interior with figures, perhaps the artist's earliest attempts at the subject. Some small notepads also survive, full of charcoal sketches of people in church. Cecily Langdale has noted that the church drawings become increasingly economical, focusing in on small groups or individual members of the congregation. According to Langdale, the artist sketched while at church and then, in the studio, made copies of the drawings, sometimes altering the scale or making additions. The sketches were then painted over in watercolour, creating different versions of the same composition. There was also a further development in her work from the fluid drawings washed with watercolour of the 1910s to a later use of gouache and heavy outlines, as in *Nuns and Schoolgirls Standing in Church* (fig.51). Again, this seems to suggest the influence of Denis. The flat opaque qualities of gouache which made it suitable for design also meant that it was useful for a religious art in which, as Denis had stressed, formal arrangement and

50 *Mère Poussepin Seated at a Table c.*1915 Oil on canvas 88.3 × 65.4 (34¾ × 25¾)
National Museum of Wales

development were important. Denis used gouache himself, and in 1911 had an exhibition in Paris solely of work in this medium. Gwen John's late gouaches experiment with simplified composition and with a restricted colour range. She seems to have enjoyed juxtaposing the shapes of the hats and the nuns' coifs, and often abbreviated features and forms with wit and playfulness. Denis's article of 1917 also stressed the importance of drawing exercises, such as working from memory and repeating compositions, a practice evident in Gwen John's sheet of drawings of *St Thérèse and her Sister* (fig.52), one of over a hundred surviving sheets of sketches on paper from the Grands Magasins du Louvre, many of which were dated by the artist between 1928 and 1933. That Gwen John should make repeat drawings on such a theme using paper from a *grand magasin* reading-room emphasises the Parisian modernity of subject and method.

Gwen John's religious work was shown at important exhibitions. The artist's *Girl Reading at the Window* was exhibited at the Armory Show where Cézanne's *Old Woman with a Rosary* was also seen. Although in France Denis had been arguing for a return to a Catholic art from the 1890s, French religious art seems to have attained heightened significance after the 1914–18 war. Catholicism was perceived by some as a source of national identity and pride, and was implicated in the feeling of a need for post-war restoration. Gwen John chose to exhibit a portrait of Mère Poussepin (accompanied by a number of drawings) for her debut at

51 *Nuns and Schoolgirls Standing in Church c.*1920s
Gouache and watercolour on paper
18.5 × 14.5
($7\frac{1}{4}$ × $5\frac{3}{4}$)
National Museum of Wales

52 Sheet of
drawings of
*St Thérèse and her
Sister, with a
Woman Drinking
from a Cup* 1930
Ink on paper
18.4 × 14 (7¼ × 5½)
National Museum of
Wales

the Salon d'Automne in 1919, the first Salon since the outbreak of war. By 1922 a *Section d'art religieux* had been organised, and several years later the Salon's president noted that this had become one of the most successful of the specialist areas. At Gwen John's exhibition at the New Chenil Galleries the first sixteen pieces were all studies in church, and among the religious paintings she included were two portraits of Mère Poussepin. The prominence which Gwen John gave to her religious work at exhibitions, and Denis's labelling of his art as 'new' and 'modern' in the titles of his collections of writings, suggests that we should be wary of perceiving such work as a contrast to more 'progressive' European art of the same period. The response of one visitor to Gwen John's Chenil exhibition emphasises this point. Michel Salaman, who had trained with the artist at the Slade, wrote a letter of praise: 'there is nothing antique

or archaistic about your work. They are so intensely modern in all but their peacefulness.'

The manner in which Gwen John represented women in a religious context can be interpreted as particularly modern. As Anne Higgonet has noted, the Virgin Mary had become increasingly important in French Catholic discourse from the mid-nineteenth century. Mary's image, circulated in various forms, from fine art to engraved religious cards, celebrated her role as a mother, and was used by the church as a powerful role model. Denis reflected the contemporary religious cult of the Virgin Mary in his paintings of Mary with her child, modelled on his own family, and of Annunciations and Visitations. Although women were an important subject for his religious paintings, according to Denis in *Notes sur la peinture religieuse* there were two types of contemporary religious art, identifiable as bad or good, and these were divided by gender. Weak paintings of sentimental scenes of intense religious emotion, such as first communion, he characterised as an expression of a feminine Catholicism, while the modern artistic expression of faith which he extolled was, by implication, masculine. This leads us to question how a Catholic artist such as Gwen John could intervene in an artistic religious discourse which was characterised as modern but, at the same time, for women, could be perceived as extremely exclusive and conservative. It is certainly noticeable that of all the pieces of Gwen John's extant work which can be understood as religious, there is only one small group of stylised sketches of the Madonna and Child, the subject of so many other artists working in the field. In fact, in her reworking of the Dürer Virgin the artist removed the infant, and chose to transplant Mary's recognisable features into a painting of an important event in the Virgin's life before the arrival of her child. Gwen John's Mère Poussepin series represents a powerful woman of the church. Denis had argued that the church should have a role in supporting and making use of modern art, and here a women's religious order had asked a woman artist to paint their foundress. Gwen John also made numerous paintings of female sitters which have a religious significance. There are four versions of the painting which the artist titled *The Pilgrim* (fig.53), two of which show the model holding a rosary. The painting which Gwen John titled *The Precious Book* (fig.54) updates medieval images of the female saints reading from volumes protected by cloth, such as Van der Weyden's *The Magdalene Reading* (fig.55). Although women with books had been an important subject for Gwen John from her early career, she had moved from representing a secular student, to portraying a woman reading a book which is a valuable repository of religious meaning. Among the artist's last oils is a painting of a girl praying. In Gwen John's work feminine piety is not attached to maternity, as in so much French Catholic discourse and art. She wrote: 'We don't go to Heaven in families now – but one by one', and, through her work, represented the faith and religious significance of women as individuals.

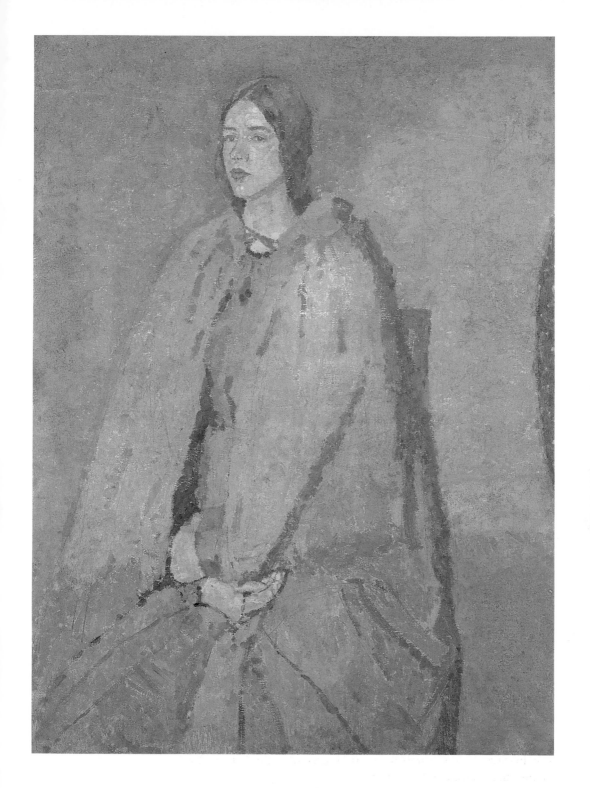

53 *The Pilgrim c.*1918–*c.*1922 Oil on canvas 73.6 × 53.3 (29 × 21)
Yale Center for British Art

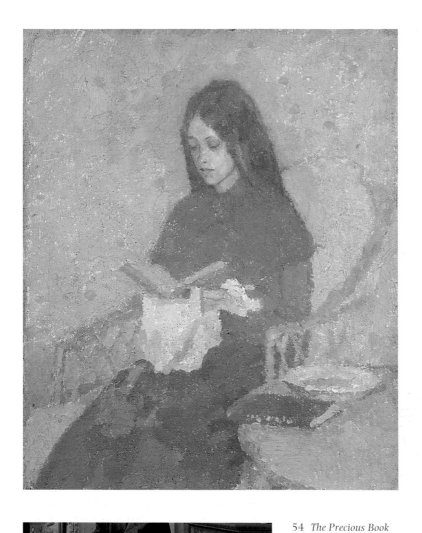

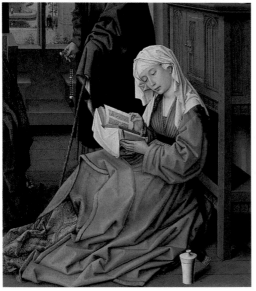

54 *The Precious Book*
*c.*1920–6
Oil on canvas
26.4 × 21 (10½ × 8¼)
Private Collection

55 Rogier van
der Weyden,
The Magdalene Reading
*c.*1440
Oil on wood
61.6 × 54.6
(24¼ × 21½)
National Gallery,
London

6

WOMEN AND GIRLS

From the Mère Poussepin series of the 1910s until the end of her career, the majority of Gwen John's paintings are portraits of women and of girls, painted using a similar technique, and arranged in variations of the same pose. They are constructed in a pattern of close tones, and represented approximately three-quarter-length and sitting in a room. The interior is usually indicated by no more than a geometric tonal arrangement suggesting a corner with a window, or a wall against which the model is placed. The figures are monumental. Their dress, often a block of one colour, and their simply arranged hair, adds to the weight of their presence which is also sometimes emphasised by the artist's distortion of the size of their hands or heads, or the length of their bodies. They sit, calm and impassive, in the centre of the canvas. How do such seemingly timeless portraits fit into a period in history in which there was the massive upheaval of war, and during which new images and ideas of femininity were formed, and how does placing them there affect our interpretation?

During the 1914–18 war there was a shift in French culture, which reached its height following the armistice. Critics have noted the return to an idea of classicism on the part of many artists who had been leading members of the pre-war avant-garde. Jeanne Robert Foster, writing to John Quinn about her visits to Parisian exhibitions in the early 1920s, noted: 'There is very little cubism, very little of the distortion of the new school, the whole trend is towards conservatism. Even Matisse leans that way at present.' The change was labelled the 'rappel à l'ordre' – the call to order – by the writer Jean Cocteau in the mid 1920s, although as his 1912 collection of essays subtitled 'Vers un nouvel ordre classique' indicates, Maurice Denis had been arguing for such a move even before the start of the conflict. The motives for this shift have been suggested as being a mixture of a rejection of the machine age and modernity, seen as in part responsible for the war, a longing for peace, and also a resurgence of patriotism, because classical culture was seen as rooted in the Latin countries. In terms of the type of art produced, certain common strands have been identified, although it is important to emphasise that in working through these concerns artists did not produce homogenous results. Numerous artists seem to have looked backwards for inspiration, referring to artistic traditions, and returned to conventional studio practice rather than working with experimental materials and methods. There was a new emphasis on creating images of beauty and contemplative tranquillity. Although the classical revival has sometimes been seen as a retrograde move, Elizabeth Cowling has cautioned against an easy interpretation of it

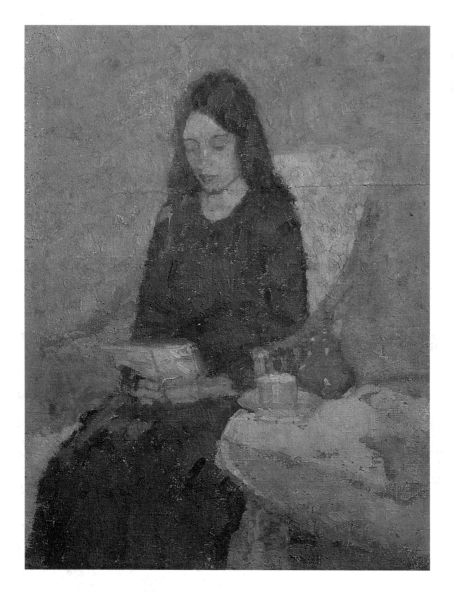

56 *The Convalescent*
1918–19
Oil on canvas
33.7 × 25.4
(13¼ × 10)
Tate Gallery

in such terms. She argues that in some ways this was a highly creative and productive period in cultural history. And of course when considering women artists such as Gwen John as part of the 'call to order', the situation is more complicated still. Women were in a different position in relation to ideas of what was modern. Many of the pre-war avant-garde movements had been exclusively male, and so for women could, in fact, be perceived as retrogressive. Although Gwen John's is not a case of radical change to a readoption of traditional representational techniques and subjects, locating her art within this period helps us to understand the significance she gave to making images of women and girls, and suggests the ways in which they were received.

In about 1918 Gwen John began a series of eight closely related paintings of a young woman reading a letter and sitting in a wicker chair, which

are collectively known as *The Convalescent* (fig. 56). The title was given by the artist to one of the paintings in 1919 and it also appears, in her own hand, on a sketch of the composition dated 1929. Although the meaning of the subject in relation to Gwen John's personal life has been discussed, in that one of her friends was gravely ill when she started work on the series, it also has a wider significance. Illness had been a theme in European painting from the nineteenth century but the image of a convalescent woman had new resonance in post-war France. It can be interpreted as an allegory of the recovery and restoration of the country itself. There is a strong artistic precedent for such a reading in the work of Puvis de Chavannes, for whom Gwen John had stated her admiration emphatically in a letter to John Quinn of 1911: 'surely he is the greatest painter of the century?' In the early 1870s Puvis de Chavannes had made two paintings, *Le Pigeon* and *Le Ballon*, in which a woman in a long, plain, dark dress, and with smooth hair, symbolised the city of Paris during the Franco-Prussian war. His two paintings of *Hope*, from the same period, represent a young woman clothed and then nude. The nude is situated in a landscape in front of ruined buildings and wooden crosses, and she symbolises the hope for regeneration. Gwen John's awareness of what would be likely to receive a favourable reception in the context of the war is also evident in the series of likenesses of male military and diplomatic figures which she drew from newspaper photographs in 1915–16 and sent to John Quinn in order to sell, which are unique among her subject matter (fig. 57).

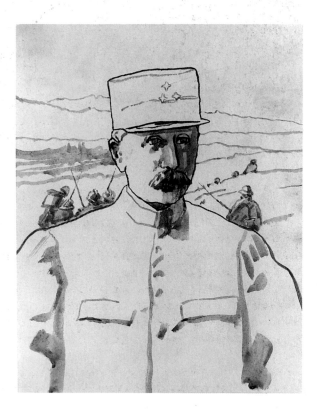

57 *General Pétain*
1915–16
Grey watercolour
wash on paper
28.1 × 22.4
(11 × 8¾)
Private Collection

In the French cultural 'call to order' it was images of women which were to become especially significant. Romy Golan has discussed the importance given to the female nude in France after 1918. There was a vogue for representations of full-figured women, which she has suggested were seen as symbolic of the French earth as female, natural, and fertile, in contrast to man-made destruction. Renoir's late paintings of voluptuous women became fashionable, and were shown as part of his retrospective at the Salon d'Automne in 1920. Gwen John had earlier commented to John Quinn that she was 'charmed' by Renoir's art. André Dunoyer de Segonzac, whose work Gwen John admitted she 'liked ... very much', so much that she asked Quinn to introduce her to the artist in the early 1920s, painted his female nudes in heavy textural paint. The female nude was also a subject of André Lhôte's art during the same period, whose work Gwen John is known to have admired. It seems that she studied, briefly, at his Académie in Montparnasse, which opened in 1922, as did her friend from the Slade, Gwen Salmond. Gwen John's papers from the 1930s often refer to Lhôte, who married a modern style influenced by Cézanne and by Cubism with classical subject matter. He is reported as saying that he had 'never painted a guitar nor a tobacco-package'. The generous curves of his female nudes fill the canvas, but they also have an underlying geometrical structure.

Gwen John also painted the female nude during the early 1920s; there are three extant paintings, two of which are unfinished. These paintings all represent the same woman. The artist deployed the technique she had developed, with its influence of Cézanne, and the paintings are constructed in touches of a subtle combination of pink, ochre and grey-blue paint. However, Gwen John's model holds her narrow body upright; she is poised and tense. In a half-length drawing of a nude girl, the young sitter crosses her arms protectively over her chest. These are not curvaceous women in 'natural' poses as favoured by many other artists of the period. As Golan remarks, moves to celebrate the female nude as 'nature' can be seen as a retreat from the advances towards emancipation made by women in France during the war. Although Gwen John may have known and admired the work of Renoir, de Segonzac and Lhôte, she seems to have refused this type of representation in her own paintings.

A particular type of image of feminine fertility and nurturing, the *maternité*, became ubiquitous in French culture in response to anxiety about the fatalities of war and the birth rate. In Paris in 1921 there was even an *Exposition nationale de la maternité et de l'enfance*. Kenneth Silver has noted the new presence of paintings of mothers with children in the work of some artists who had been associated with the avant-garde before 1914, including Picasso and the Futurist, Severini. Although Gwen John did not make such images, she did paint portraits of individual girls, who, when she titled the paintings, are referred to as *enfant* or *jeune fille*. These include *Girl in Rose* (fig.58) which was shown at the 1924 Salon des Tuileries. It is tempting to read Gwen John's focus on making paintings of girls rather than boys as a reflection of her own life and of her childhood, or

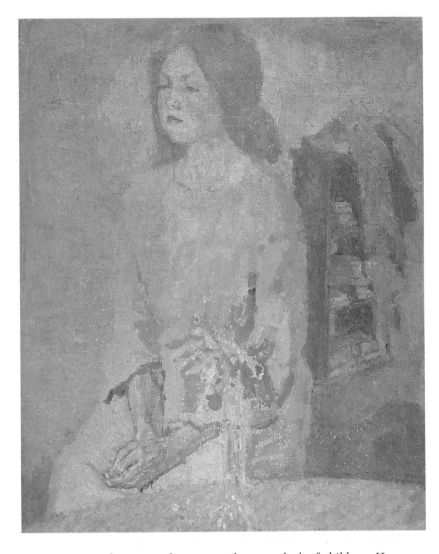

58 *Girl in Rose*
late 1910s
Oil on canvas
46.3 × 36.2
($18\frac{1}{4}$ × $14\frac{1}{4}$)
Private Collection

as a symptom of a personal sorrow at her own lack of children. However Cézanne himself had painted portraits of girls sitting with dolls on their laps, one of which was reproduced in Vollard's 1914 book on the artist. It is also useful to consider the wider culture of the period. Stéphane Michaud has identified the emergence of the little girl as a distinct being with her own identity in British and French literature as dating from as recently as the mid-nineteenth century onwards. So, though we might interpret them biographically, Gwen John's paintings of girls are also very much part of their age.

There is also an important series of drawings of children by Gwen John from the same period, many of which are of girls (fig. 59). Cecily Langdale's study of the drawings suggests that they are mostly Breton peasant children, made during Gwen John's long visits to Pléneuf, on the coast, in 1918 and 1919. In several drawings the young sitters are outside, one girl's wind-blown hair is carefully sketched in, and another is silhouetted

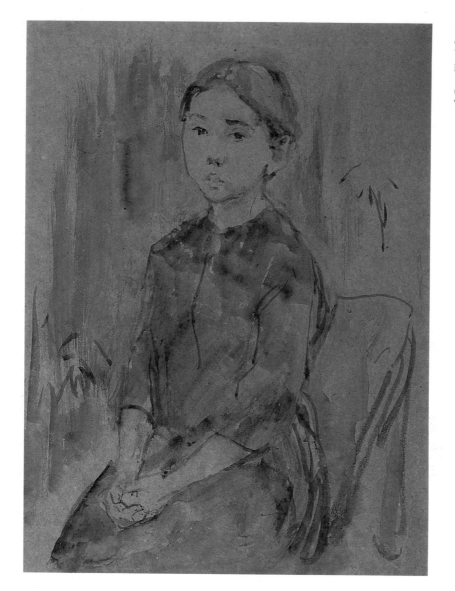

59 *Study of Child*
c.1915–20
Watercolour on
paper
32.4 × 25.1
(12¼ × 9¾)
Tate Gallery

against the sea. Images of plainly dressed country children are likely to
have appealed to a post-war taste for ruralism and simplicity in France. In
Gwen John's drawings this idea of naturalness is combined with the
depiction of child models who are obviously posing for their portraits,
emphasising that the drawings are considered pieces of art rather than
informal *plein air* sketches. Again, this locates them within contemporary
culture. Drawing, and particularly portrait drawing, was given a new
importance and popularity in France as part of the classical revival, and
has been explained by Kenneth Silver as an artistic return and reference to
a traditional discipline. Gwen John certainly exhibited many of her draw-
ings, and with some success, during this period. She included nine,
identified by Cecily Langdale as probably all Breton children, with her first

60 *Girl with Cat*
c.1918–c.1922
Oil on canvas
34.9 × 26.7
($13\frac{3}{4}$ × $10\frac{1}{2}$)
The Metropolitan
Museum of Art,
Bequest of Joan
Whitney Payson,
1976

submission to the Salon d'Automne in 1919. In 1920 she exhibited thirteen drawings at two different Parisian Salons, selling nearly all of them. A *Portfolio of Studies of a Child* was also shown as part of her solo exhibition in 1926.

Where Gwen John's work seems to have most in common with the 'call to order' is in her portraits of female sitters in interiors, such as the painting exhibited as *Enfant et chat* at the Salon d'Automne of 1921 (fig.60). These recall Cézanne's portraits, for example his *c.*1892 painting of his wife, which was exhibited at the 1904 Salon d'Automne and reproduced in Vollard's book (fig.61). As late as 1936 Gwen John wrote to Ursula Tyrwhitt describing a volume on Cézanne as 'very precious' to her. The date suggests that the book was perhaps Lionello Venturi's catalogue raisonné, the first to be compiled, which was published in Paris in that year. Looking backwards for inspiration was of course part of the return to

classicism. Cézanne's critical reputation as a great French painter was being established by the late 1900s, and Gwen John's obvious admiration associated her with the art of her adopted country – an affiliation which was nearly given a formal acknowledgement when she was nominated as a Salon Associataire in about 1919, only to be rejected when it was realised that she was not in fact French. Particular characteristics of Gwen John's later work indicate Cézanne's influence, in addition to the similarity in the rhythmic handling of paint.

During the early 1920s Gwen John painted a series of portraits of a young woman in a mulberry dress (fig.62). In the version which she sold to John Quinn, and so must have considered complete, there are large unpainted areas in the figure's skirt and in the background. Several other paintings have a similar unfinished quality, and even in those works which have the appearance of completion, the canvas often shows through where the paint has been dragged over it. This creates a sense of immediacy and also draws attention to the actual process itself. In 1907 Maurice Denis had commented on the 'moving sight' of Cézanne's 'unfinished' canvases, interpreting them as evidence of the artist's struggle. In addition Gwen John began to use distortion, altering the size of different parts of the figure to exaggerate the monumental effect. Again this seems to follow Cézanne's manipulation of forms and spaces to suit the needs of his compositions, also discussed by Denis. Gwen John summarised the importance of formal structure in art in a letter to Ursula Tyrwhitt of around 1936: 'I said a cat or a man its the same thing ... I meant its an affaire of volumes. That's saying the same thing as l'Hote [sic] said when he said the object is of no

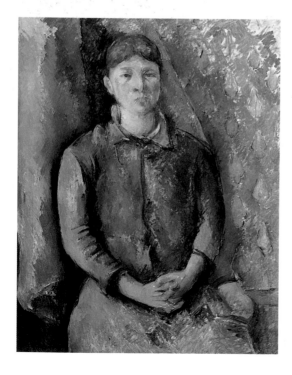

61 Paul Cézanne,
Madame Cézanne c.1892
Oil on canvas
100 × 81 (39½ × 32)
Detroit Institute of Arts,
Bequest of Robert H.
Tannahill

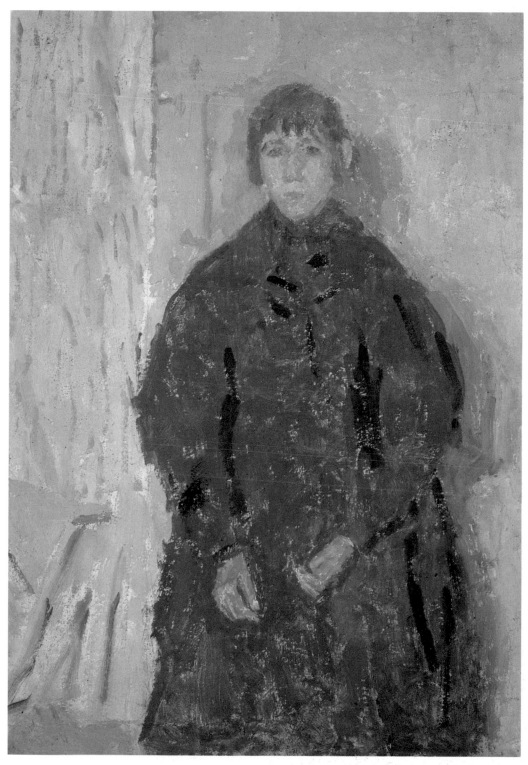

62 *Girl in Mulberry Dress c.* 1923–4 Oil on canvas mounted on panel 54.6 × 37.5 (21½ × 14¾)
Southampton City Art Gallery

importance.' The cat which she mentions, which features in some of her work, also appears in other images of French domestic interiors. A cat stalks across the bottom of Bonnard's *The Bowl of Milk* (fig.63) shown at the Salon des Indépendants in 1920, in which, as in Gwen John's paintings, the representation of a woman in an interior is an image of monumental solidity and intense stillness. Colour in Gwen John's later paintings is more subdued than that used by Bonnard during the same period, and, for that matter, that used by Cézanne in much of his work. Gwen John continued to use tiny shifts of tone within a restricted colour range, rather than strong colour

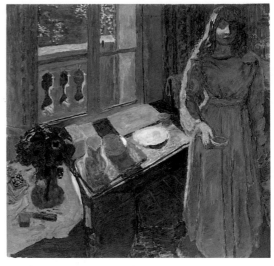

63 Pierre Bonnard, *The Bowl of Milk* c.1919 Oil on canvas 116.2 × 121 (45¾ × 47¾) Tate Gallery

contrasts, to create volume and space. Nevertheless a new method of working-out colour combinations is detectable in her later work. Some of her drawings and watercolours are annotated with numbers, which refer to specific colours, as in the drawing which appears to be a study for *Enfant et chat* (fig.64). The use of mathematical formulation in art had been advocated by Denis, for whom *le nombre* represented nature's essence and corresponded with religious truth. The 'call to order' was also favourable to the idea of using precise measurement and organisation in order to create harmony. Gwen John described using an extremely detailed numbered disc which allowed her to find 'the colours and complementary tone of any colour and tone'. But her approach to colour was not merely clinical; rather she seems to have followed Denis's belief that a system of meticulous calculations and balances was necessary in order to create beauty. Mary Taubman has remarked on the 'poetic allusiveness' of Gwen John's colour notes such as 'April, faded panseys [*sic*] on the sands at night'. These appear jotted down among her papers, and sometimes even written onto drawings and watercolours themselves. In these descriptions, or reminders to herself, we can perceive an echo of Rilke's reaction to Cézanne's art at the Salon d'Automne in 1907. For Rilke, Cézanne's work opened his eyes to a new awareness of the evocative power of colour. The artist's work led the poet to consider writing a monograph on the colour blue, and in his descriptions of the paintings Rilke tried to formulate the written equivalent of what he had seen, in the case of a Cézanne self-portrait 'a moist-violet brown contending against a wall of grey and pale copper'.

Three paintings which Gwen John made during the period of the late 1910s to early 1920s show the artist at work with different carefully organised colour schemes. These range from the blue/grey and brown of the *Girl Posing in a Hat with Tassels* (fig.65), to the *Girl in Rose*, and the dark and sombre shade of the gown which dominates the painting of the *Girl in Mulberry Dress*. We can identify themes in these paintings which Gwen John carried through from her earlier work. The girl in the hat is holding

a book, and the *Girl in Rose* sits in front of a bookcase containing piles of volumes. In *Girl in Mulberry Dress* there is an indication that the setting is an artist's studio; what appears to be a stack of canvas stretchers leans against the wall next to the model. And in all three paintings costume is important. It is given particular significance in the portrait of a young woman wearing a large hat. The edge of her shawl is carried on into the interior where the walls meet the floor. Her dress determines the organisation of the space around her. Locating these paintings within this historical period raises a question about the appearance of the women represented. Why, at the dawn of the age of the flapper, or in France, *la garçonne*, did a woman artist not represent women with what we could understand as a more modern look? The answer seems to lie partly in the French 'call to order', in which aspiration to a representation of timelessness *was* the way forward, and also in the artist's critical distance from contemporary images of fashionable femininity, which she maintained throughout her work. In all three paintings great care is given to composition and colour. Gwen

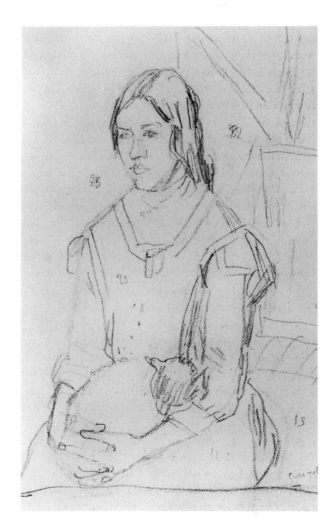

64 *Girl Holding
a Cat*
c.1918–c.1922
Pencil on paper
25.1 × 16.2
(10 × 6½)
Private Collection

65 *Girl Posing in a
Hat with Tassels*
c.1918–c.1922
Oil on canvas
46.3 × 39.4
($18\frac{1}{4} × 15\frac{1}{2}$)
Private Collection

John's explanation of Lhôte's theory to her friend indicates that she interpreted it as a statement of the importance of formal concerns. But she also seems to step back from Lhôte's assertion that the object was of no importance, suggesting that formal arrangement was not an end in itself, that what was being drawn or painted was also significant. And although it becomes clear that we cannot interpret all Gwen John's art as having one meaning, it is possible to identify one subject which was more important to her than any other, the female sitter, and the possibilities for portraying her.

Chronology

1876
On 22 June Gwendolen Mary John is born in Haverfordwest, Wales. She has an older brother, Thornton, born in 1875. In 1878 there follows another brother, Augustus, and in 1879, a sister, Winifred. Their father, Edwin, is a solicitor, and their mother, Augusta, an amateur painter.

1884
Augusta John dies and the family move to Tenby. Gwen John is educated first by governesses, and then at school in Tenby.

1895–8
Gwen John studies at the Slade School of Fine Art, London, where her brother, Augustus John, is also a student. She wins a certificate for figure drawing and a prize for figure composition. Her lifelong friendship with the artist Ursula Tyrwhitt begins.

1898
September, visits Paris for the first time with two of her friends from the Slade, Ida Nettleship and Gwen Salmond. She stays in Montparnasse and studies at James McNeill Whistler's Académie Carmen.

1899
Returns to London, where she lives in a series of lodgings until 1903.

1900
Makes her debut as an exhibiting artist with *Portrait of the Artist* shown at the New English Art Club (NEAC) in London; a critic remarks that the painting has some 'notable qualities'. During this, and the next two years, she will exhibit at each of the NEAC's bi-annual shows. October, Gwen John travels to Le Puy en Velay for a holiday with her brother, Augustus, and Ambrose McEvoy, a contemporary of theirs at the Slade.
Exposition Universelle held in Paris.

1901
Ida Nettleship marries Augustus John.

1902
Sells a self-portrait to Frederick Brown of the Slade.

1903
Has a joint exhibition with Augustus at the Carfax Gallery where she exhibits three paintings including a portrait of Ursula Tyrwhitt, now lost. Summer, travels to France with Dorelia McNeill where they embark on a walking tour, making a living by sketching the people they meet. They intend to travel to Rome, but get as far as Toulouse where they spend the winter. Paints several portraits of Dorelia.

1904
The two women travel to Paris where, living in Montparnasse, Gwen John begins to work as a model. She poses for Auguste Rodin, with whom she has an affair, and for other artists. Becomes acquainted with a number of artists working in Montparnasse. She stays briefly at the apartment of Mary Constance Lloyd, a painter and designer whom she remains in contact with for the rest of her life. By November moves to 7 rue St Placide. *There are major exhibitions of the work of Pierre Puvis de Chavannes and Paul Cézanne at the Salon d'Automne.*

1905
During this period attends the Académie Colarossi.

1906
Around this time Gwen John meets the poet Rainer Maria Rilke who acted as Rodin's secretary for a period, they become friends and he lends her books, including his own work.

1907
Moves to 87 rue du Cherche Midi. Ida Nettleship John dies in Paris after the birth of her fifth child. *Two exhibitions of Cézanne's work are held in the French capital, a memorial exhibition at the Salon d'Automne and an exhibition of watercolours at Bernheim-Jeune's.*

1908
Portrait of Chloë Boughton-Leigh, a friend who makes regular visits to Paris, is shown at the NEAC exhibition, where it is singled out by a critic as 'one of the greatest achievements' in the show.

1909
Moves to 6 rue de l'Ouest, Montparnasse. Begins her two paintings of Fenella Lovell, nude and clothed. Exhibits at the NEAC.

1910
Correspondence with the American art collector John Quinn begins. He becomes a keen patron of Gwen John's work and also solicits her opinion on his other art purchases in Paris. Exhibits at the NEAC.

1911
Moves to 29 rue Terre Neuve, Meudon, maintaining her room at 6 rue de l'Ouest as a studio. Exhibits at the NEAC. Two of Gwen John's paintings are acquired by the Contemporary Art Society in London.

1912
Admires the work of the Futurists, who have their first exhibition in Paris. Maurice Denis publishes a collection of his writings on art, *Théories 1890–1910: Du Symbolisme et de Gauguin vers un nouvel ordre classique*.

1913
The painting *Girl Reading at the Window*, which Gwen John had sold to John Quinn, is included in the Armory Show, New York. She is received into the Catholic Church and begins a series of paintings of Mère Marie Poussepin, foundress of the order of the Dominican Sisters of Charity who have a convent at Meudon. She also begins to draw in church.

1914
Outbreak of war.
Gwen John remains in Paris. Her friend, the artist Ruth Manson, and her daughter Rosamund stay with Gwen John at rue Terre Neuve for a time, and over the next few years they share holidays in Brittany.

1917
Death of Auguste Rodin.

1918
Visits Pléneuf in Brittany, twice. She makes a series of drawings of the local children.
Women over the age of thirty are given the vote in Britain.

1919
Returns to Paris from Brittany and makes her Parisian debut as an exhibiting artist at the Salon d'Automne with nine drawings and a painting of Mère Poussepin. At about this time begins the series of paintings of *The Convalescent*.
Treaty of Versailles.

1920
Exhibits at three different Parisian Salons. Jeanne Robert Foster, poet and lover of John Quinn spends time in Paris with Gwen John. Foster writes to Quinn about Gwen John's meeting with Henri Matisse, and notes that the American painters of her acquaintance 'all knew of Miss John … and the Salon takes all she will send them'. Quinn begins to pay Gwen John an annual stipend in return for some of her work.

1921
Exhibits at the Salon d'Automne. Visits England and stays with the poet Arthur Symons and his wife. Meets John Quinn for the first time in Paris. Around this time meets Pablo Picasso and Georges Braque.

1922
Five of Gwen John's paintings from Quinn's collection are included in the exhibition *Seven English Modernists* at the Sculptors' Gallery, New York. The exhibition includes work by Augustus John, J.D. Innes, Wyndham Lewis, Jacob Epstein and Henri Gaudier-Brzeska. Maurice Denis publishes his *Nouvelles théories sur l'art moderne sur l'art sacré*.

1923
Exhibits at the Salon d'Automne. John Quinn and Jeanne Robert Foster travel to Paris. In their company Gwen John visits Constantin Brancusi and André Dunoyer de Segonzac.

1924
Exhibits at the Salon des Tuileries after being invited to show her work there without having to pass before a selecting jury. Exhibits at the Salon de la Société Nationale des Beaux Arts. John Quinn dies.

1925
Exhibits at the Salon de la Société Nationale des Beaux Arts.

1926
Has a solo exhibition at the New Chenil Galleries. As a foreword to her catalogue she chooses a *Pensée sur l'art* by Maurice Denis, which refers to Cézanne, and which she has included in French. Her exhibition includes a large number of her works on religious subjects. Mary Chamot titles her review of the exhibition *An Undiscovered Artist*. Buys property at 8 rue Babie, Meudon, maintaining apartment at rue Terre Neuve. Buys a cottage in Hampshire.

1927
Makes a visit to her cottage in England, and sees her brother Augustus and his family. From the late 1920s until the early 1930s she makes a series of drawings on paper from the Salon de Lecture of the Grands Magasins du Louvre.

1928
Visits England. From the beginning of this year until the following year sends a drawing every week to Véra Oumançoff, sister-in-law of the theologian Jacques Maritain; they both live near the artist in Meudon.

1929
John Quinn's sister, Julia Quinn Anderson, travels to Meudon to see Gwen John, and visits again over the next few years. She has bought five of Gwen John's paintings from the sale of her brother's collection, and buys at least one painting directly from the artist.

1931
Travels to England to visit Edith Nettleship, sister of Ida, who is dying. Visits a convent near Brussels with Chloë Boughton-Leigh this, and the following, year.

1936
Attends the classes of the artist and art theorist André Lhôte, her notes and letters from around this time refer to his theories.

1939
Gwen John dies in Dieppe on 18 September.

1945
Women vote for the first time in the French elections.

1946
Memorial exhibition of Gwen John's work held at the Matthiesen Gallery, London, and retrospective held by the Arts Council of Great Britain.

Select Bibliography

Aish, Caroline and Rolley, Katrina, *Fashion in Photographs 1900–1920*, London 1992.

Beckett, Jane and Cherry, Deborah, 'Gwendolen Mary John (1876–1939)', *Art History*, 2–3, 1988, pp.456–62.

Bouvet, Francis, *Bonnard: The Complete Graphic Work*, London 1981.

Busch, Günter and von Reinken, Liselotte, *Paula Modersohn-Becker: The Letters and Journals*, Illinois 1990.

Cachin, Françoise, and others, *Cézanne*, exh. cat., Tate Gallery, London 1996.

Cogeval, Guy, Denis, Claire adn Banuel, Thérèse, *Maurice Denis (1870–1943): From Symbolism to Classicism*, Liverpool 1994.

Cowling, Elizabeth and Mundy, Jennifer, *On Classic Ground: Picasso, Léger, de Chirico and the New Classicism 1910–1930*, exh. cat., Tate Gallery, London 1990.

Elliott, Bridget and Wallace, Jo-Anne (eds.), *Women Artists and Writers: Modernist (Im)positionings*, London 1994.

Fothergill, John, *The Slade*, London 1907.

Fraisse, Geneviève and Perrot, Michelle (eds.), *A History of Women in the West: Vol.4, Emerging Feminism from Revolution to World War*, Cambridge Mass. and London 1993.

Gardner, Viv and Rutherford, Susan, *The New Woman and her Sisters*, London 1992.

Golan, Romy, *Modernity and Nostalgia: Art and Politics in France between the Wars*, New Haven and London 1987.

Langdale, Cecily, *Gwen John: With a Catalogue Raisonné of the Paintings and a Selection of the Drawings*, New Haven and London 1987.

Lloyd-Morgan, Ceridwen, *Gwen John: Papers at the National Museum of Wales*, Aberystwyth 1988.

Maynard, Margaret, 'A Dream of Fair Women: Revival Dress and the Formation of Late Victorian Images of Femininity', *Art History*, 12–13, 1989, pp. 322–41.

Miller, Michael, *The Bon Marché: Bourgeois Culture and the Department Store 1869–1920*, London 1981.

Perry, Gillian, *Women Artists and the Parisian Avant-Garde*, Manchester 1995.

Rilke, Clara (ed.), *Rainer Maria Rilke Letters on Cézanne*, Cape 1988.

Ritchie, Andrew Carnduff, *Edouard Vuillard*, New York 1954.

Silver, Kenneth E., *Esprit de Corps: The Art of the Parisian Avant-Garde and the First World War, 1914–1925*, Princeton 1989.

Silverman, Debra, *Art Nouveau in Fin-de-Siècle France*, Berkeley 1989.

Taubman, Mary, *Gwen John*, Aldershot 1985.

Thomson, Belinda, *Vuillard*, London 1991.

Vad, Poul, *Vilhelm Hammershøi and Danish Art at the Turn of the Century*, New Haven and London 1992.

Photographic Credits

Copyright Credits

Index